HIGH COUNTRY

Touring the Colorado Rockies

SUSAN M. NEIDER

FALCON®

GUILFORD, CONNECTICUT
HELENA, MONTANA

AN IMPRINT OF THE GLOBE PEQUOT PRESS

To the memory of my parents,
Charles Neider and lovely Joan Merrick

To buy books in quantity for corporate use
or incentives, call **(800) 962–0973, ext. 4551,**
or e-mail **premiums@GlobePequot.com.**

Text design: M.A. Dubé
Photo credits: Photos on p. 14 (top), p. 26, p. 47 (bottom), and p. 109 (bottom) by Daniel M. Levine; photo on p. 36 (top) by Annie N. Donnelly. All other photos are by the author.
Maps created by Daniel M. Levine

Library of Congress Cataloging-in-Publication Data
Neider, Susan M.
 High Country : touring the Colorado Rockies / Susan M. Neider.
 p. cm.
 ISBN: 0-7627-3647-X
 1. Rocky Mountains—Tours. 2. Rocky Mountains—Pictorial works. 3. Outdoor recreation—Rocky Mountains—Guidebooks. 4. Colorado —Tours. 5. Colorado—Pictorial Works. 6. Outdoor recreation—Colorado—Guidebooks. I. Title.

F782.R6N45 2005
917.804—dc22 2005040491

Manufactured in China
First Edition/First Printing

CONTENTS

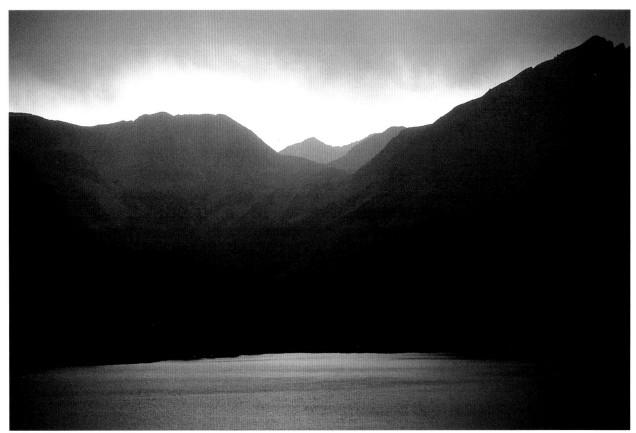

Trout Lake, near Lizard Head Pass

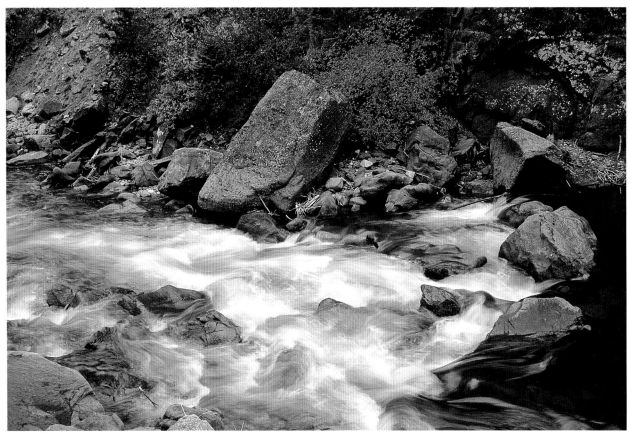

Crystal River near Hays Creek Falls

PREFACE

We are some distance out from where we once were, not so long ago. We have driven straight toward those mountains without looking back, toward the brilliant aspens and snow and the raw, empty earth with wild highlands and mysterious canyons under that great arching sky. We will climb through the Front Range from this infinite flatness where the earth is mute. No battles of rock and river were ever waged here. No violent outbursts of stone can be heard upon this land now, and the furious displays of water's temper are silent.

A hint of cobalt glows in the east, sending up crimson streamers that burst from the horizon to announce the dawn as we, with this gentle orb, roll away from the sun. The skies threaten this morning, the air bristles and snaps. Wind kicks up in furious gusts, buffeting and beating and tossing about the sagebrush while our little ship strains onward. Here and there nature flashes warning in spidery electric bolts, and long gray shafts of rain drop from thunderheads that touch the heavens with their brilliant sunny tops. Up from Denver through the foothills we sail, over great rocky waves to a place where nature suddenly changed its mind. Forcing calm to upheaval, there they are at last, rising from the plains in three classic peaks that push up from a wall of dark mountains. I see "my boys" are quiet today—no outrageous screaming for attention, no startling light, just a quiet and polite "hello" from their gentle forms in the haze and shadow of the distance.

The peaks are here, so are the valleys. So is the range of vision that draws me away from an intense and restless inner self. Rivers cut canyons through rock by thundering and smashing and beating against the resistance of granite walls to break open the glorious colors within. Rock is here to ground and shape and bear their force. Strength cradles dreamy pools and gives way under persistence, in surrender, to jagged arching forms. Here is release into unbound enormity, liberation from every urgent crying voice that is quieted by the silence of the mountains and the stillness of their silhouette, shadowy giants against a sky that never stops.

How to Use
This Book

What Are the Colorado Rockies? In brief and simple terms, the Colorado Rockies are about supreme elevation, the highest of the high peaks in the Rocky Mountain Range, the geographic spine of North America stretching from Alaska to Mexico. Its climax is found on the lofty summit of Mount Elbert in Colorado, the state that contains 75 percent of the land area of the United States with an altitude above 10,000 feet, including fifty-three "fourteeners," peaks that exceed 14,000 feet.

LOCATION: A quick reference for the park's location relative to the nearest town.

ELEVATION: Highest and lowest points within the park boundaries.

NAME: Derivation or translation, if any.

AREA/LOCAL MAPS: Illustrative guides to major roads, trails, geologic features, and park offerings. Some maps and photo captions are marked with corresponding numbered camera icons. These icons identify locations on the map where specific photographs were taken.

GEORAPHY: A brief description and explanation of the important geographic features unique to that park.

SUGGESTED LENGTH OF STAY: This should allow for ample opportunity to tour the park and revisit favorite spots. Some parks are so large and diverse that additional time will be needed for a thorough exploration or for specialized activities such as backcountry hiking and river-rafting expeditions.

BEST TIME TO BE THERE: It is generally true that landscape photographers prefer early-morning or evening light for its brilliance, clarity, and saturation. Midday light tends to be harsh, flat, and brutally hot in the summer.

HIGHLIGHTS: Each park's "greatest hits" according to the author.

COLORFUL NOTES

Unusual or little-known facts about the park.

COLORFUL COMMENTS

Little-known quotations describing the wonder and beauty of the park.

GENERAL INFORMATION

- **Fee (yes or no):** Is any fee required to enter this park?

- **Visitor center (yes or no):** Each park's official focal point for information, maps, books, and museum displays. The facility may range from a small, simple structure to a large, complex information plaza complete with talks, movies, guided nature walks, and Junior Ranger programs. The visitor center is always an essential stop in the park.

- **4WD needed (yes or no):** Is a four-wheel-drive vehicle necessary to see most of the scenic areas in the park?

- **Gas within 5 miles (yes or no):** Is gasoline available within 5 miles of this park?

- **Restrooms (yes or no):** Are restrooms available? (Some parks may not have flush toilets or running water.)

- **Food/water (yes or no):** Are drinking water and, at the minimum, a light snack available within or very near the park?

- **Convenience store (yes or no):** Does this park have a general store where basic rations and supplies can be purchased?

- **Hiking (yes or no):** Is hiking permitted in this park?

- **Camping (yes or no):** Is overnight camping permitted in this park?

- **Lodging within 5 miles (yes or no):** Are basic hotel services available within 5 miles of this park?

- **Photo rating (1 low–5 high):** This rates the relative ease with which an advanced amateur can come away with a variety of striking and satisfying images. Some parks contain regions that are very beautiful, but also very remote. If important scenic areas are difficult or dangerous to access, the photo rating will drop no matter how stunning they may be.

- **Child rating (1 low–5 high):** This rates the park's relative appeal to the curiosity and imagination of children ages six to twelve, based primarily on fun activities, interactive displays, and educational content.

Note or Caution: Additional important information or warnings.

FOR MORE INFORMATION

Complete contact information for each park.

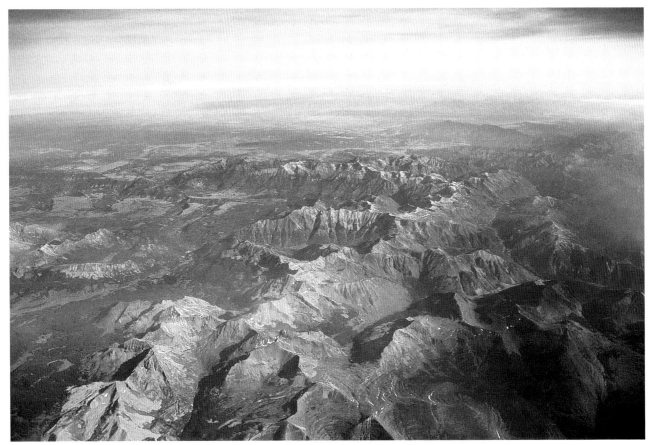

Looking south over the Colorado Rocky Mountains

THE FORMATION
of the Rocky Mountains

The Rocky Mountains are a long and high uplift of rock, the easternmost belt of the North American Cordillera, which extends for 3,000 miles from Alaska, down through western Canada and the United States, and into northern Mexico. Formed during the Mesozoic and Early Cenozoic eras, they are geologically complex and relatively young, and so less weathered by time than the older and softly rounded ranges of the eastern United States. The Rocky Mountains are just that, distinctly ragged and rocky in appearance, with sheer angular slopes capped by steep crests with sharp edges. Narrow canyons are created between peaks by their proximity and impressive vertical drop. Snowfields cover the northern ranges and the higher mountains to the south, and everywhere, erosive glaciers have left their mark in deep cuts that expose harder Precambrian crystalline cores that are rimmed by thick upturned layers of younger sedimentary rock.

The grandeur of the Rocky Mountains as we know them today is the culmination of a sequence of geologic events, the first being the formation of rock that occurred slowly over hundreds of millions of years. Originally, most of the rock formed was sedimentary in nature, created about two billion years ago from layered deposits left behind by an ancient sea. When the sea retreated, water rich in minerals filtered slowly through these deposits, gradually settling and cementing the compressed layers and, under the sheer weight of the accumulated sediment, transformed them by pressure into stone. What was once windblown sand became sandstone, finer-grained particles became siltstone, and mud and clay turned to shale.

Then, between 1.7 and 1.6 billion years ago, these sedimentary rocks became trapped and squeezed between shifting sections of the earth's crust called tectonic plates. The collision produced enormous amounts of intense heat and pressure, and under the force of this stress, a recrystallization of sedimentary into new metamorphic rock occurred. The shale, which contained mostly clay and some very fine silt, was converted into schist, and the sandstone layers were transformed into gneiss.

Much later, about 130 million years ago, tectonic plates began to collide again and subduct in a series of three uplifting thrusts along the western edge of North America. But not until seventy million years ago did these gigantic forces finally cause the buckling and uplifting of the mountains that are now the Southern Rockies of Colorado. This was a time of tremendous geologic upheaval. Layers of rock and huge slabs of earth, once continuous, were jumbled, underthrust horizontally, or displaced vertically by thousands of feet. The upward thrusts advanced, causing deep fault zones to form that strained the earth's crust and allowed magma to rise up. When it reached the surface, this molten rock erupted as volcanoes with tops that towered thousands of feet above the surrounding granite masses, which were soon buried in lava flows and beds of ash.

With upheaval comes erosion, for uplift gives water greater chiseling power in its rush-and-tumble descent to the sea. It scours, it scrapes, it sculpts, it dissolves, it seeps into joints, cracking them open by repeated freezing and thawing. It weathers softer rocks faster than hard ones and washes them away at different rates. Relentless winds blast with furious speeds, whipping up sand and dust to batter the weakened stone. Weathered and unstable, entire rock structures yield to gravity and collapse into rubble. When the earth's climate chilled about two million years ago, glaciers formed throughout the Rockies. Enormous rivers of ice carved their way down mountainsides, digging out deep U-shaped valleys and basins, and leaving behind great moraines.

THE FORMATION

Over the ages emerged a landscape so magnificent and complex that 2 miles of elevation and five life zones fail to capture it. Mountain "range" comes closest, for what incredible range—scope, magnitude, dimension—lies therein! The peaks may dominate the scene, but consider the valleys and meadows, the canyons and gorges, the plateaus, mesas, and cliffs, the lakes, rivers, and streams. Cover them with dense forests and treeless expanses, with waterfalls and sand dunes, and fill them with birds, fish, animals, and flowers. Add stretches of barren tundra, hot springs and ice fields, fossil beds, lava flows, and bizarre outcroppings of rock. And then lay them all open to the tender warmth of sunshine, the long blizzards, the hail and fog, the avalanches and flash floods, and that crisp, rarefied air.

Millions of years have shaped the Rocky Mountains into their present form, which is usually divided into five sections: the Brooks Range in Alaska, the Rocky Mountains of Canada, and, within the continental United States, the Northern Rockies, the Middle Rockies, and the Southern Rockies of Colorado, where our interest lies and where our journey begins.

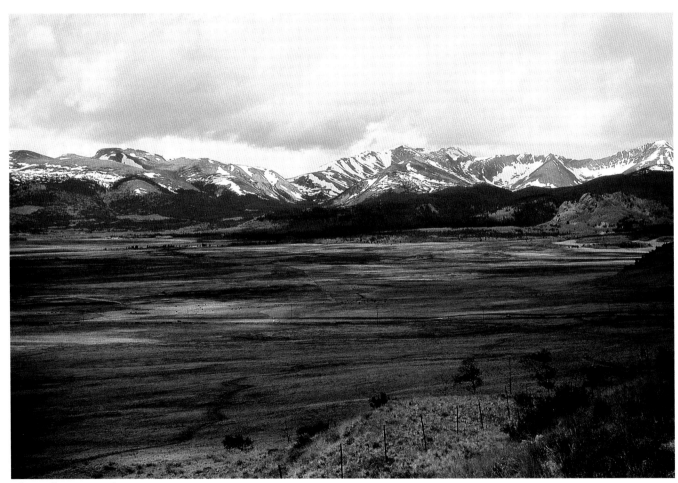

The Collegiate Peaks

THE MAJOR
Colorado Rocky Mountain Ranges

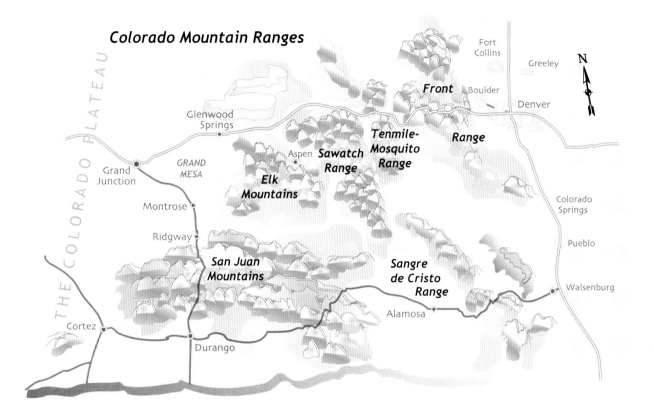

Colorado Mountain Ranges

THE COLORADO PLATEAU

COLORADO PLATEAU

Fort Collins
Greeley
N
Front
Boulder
Denver
Glenwood Springs
Tenmile-Mosquito Range
Range
Grand Junction
GRAND MESA
Aspen
Sawatch Range
Elk Mountains
Colorado Springs
Montrose
Ridgway
Pueblo
San Juan Mountains
Sangre de Cristo Range
Walsenburg
Alamosa
Cortez
Durango

ELK MOUNTAINS

Castle Peak	14,265'
Maroon Peak	14,156'
Capitol Peak	14,130'
Snowmass Mountain	14,092'
Conundrum Peak	14,060'*
Pyramid Peak	14,018'
North Maroon Peak	14,014'*

THE FRONT RANGE

Grays Peak	14,270'
Torreys Peak	14,267'
Mount Evans	14,264'
Longs Peak	14,255'
Pikes Peak	14,110'
Mount Bierstadt	14,060'

TENMILE–MOSQUITO RANGE

Mount Lincoln	14,286'
Quandary Peak	14,265'
Mount Cameron	14,238'*
Mount Bross	14,172'
Mount Democrat	14,148'
Mount Sherman	14,036'

SAN JUAN MOUNTAINS

Uncompahgre Peak	14,309'
Mount Wilson	14,246'
El Diente Peak	14,159'*
Mount Sneffels	14,150'
Mount Eolus	14,083'
Windom Peak	14,082'
Sunlight Peak	14,059'
Handies Peak	14,048'
North Eolus	14,039'*
Redcloud Peak	14,034'
Wilson Peak	14,017'
Wetterhorn Peak	14,015'
San Luis Peak	14,014'
Sunshine Peak	14,001'

SANGRE DE CRISTO RANGE

Blanca Peak	14,345'
Crestone Peak	14,294'
Crestone Needle	14,197'
Kit Carson Peak	14,165'
Challenger Point	14,081'
Humboldt Peak	14,064'
Culebra Peak	14,047'
Ellingwood Point	14,042'
Mount Lindsey	14,042'
Little Bear Peak	14,037'

SAWATCH RANGE

Mount Elbert	14,433'
Mount Massive	14,421'
Mount Harvard	14,420'
La Plata Peak	14,336'
Mount Antero	14,269'
Mount Shavano	14,229'
Mount Belford	14,197'
Mount Princeton	14,197'
Mount Yale	14,196'
Tabeguache Peak	14,155'
Mount Oxford	14,153'
Mount Columbia	14,073'
Missouri Mountain	14,067'
Mount of the Holy Cross	14,005'
Huron Peak	14,003'

** Unofficial fourteener, as it does not rise at least 300 feet above the saddle that connects it to the nearest fourteener.*

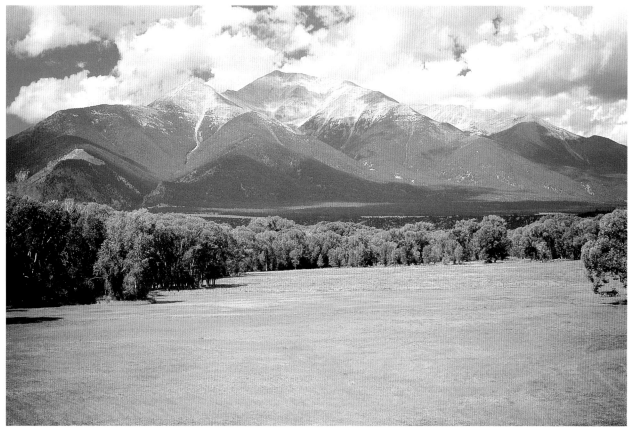

Mount Princeton in July

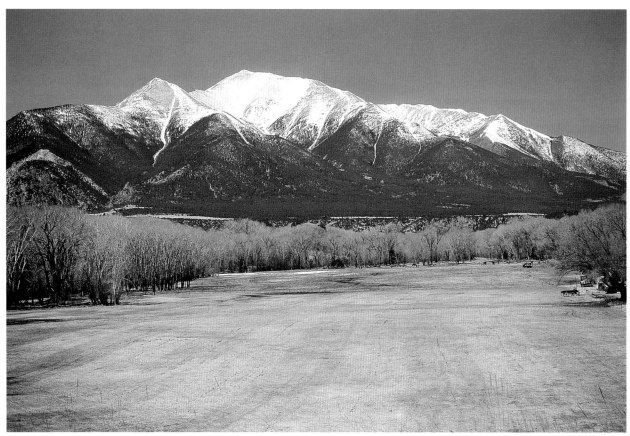

Mount Princeton in March

THE FOURTEENERS

These are Colorado's highest peaks—the jewels in the crown, at 14,000 feet and higher.

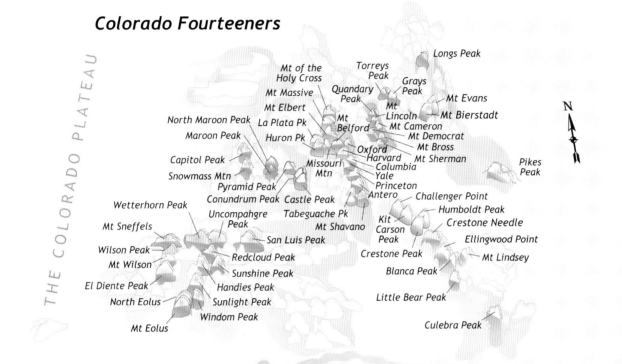

Colorado Fourteeners

Rank	Mountain	Elevation	Mountain Range	Rank	Mountain	Elevation	Mountain Range
1.	Mt. Elbert	14,433'	Sawatch	16.	Mt. Wilson	14,246'	San Juan
2.	Mt. Massive	14,421'	Sawatch	*	Mt. Cameron	14,238'	Tenmile–Mosquito
3.	Mt. Harvard	14,420'	Sawatch	17.	Mt. Shavano	14,229'	Sawatch
4.	Blanca Peak	14,345'	Sangre de Cristo	18.	Mt. Belford	14,197'	Sawatch
5.	La Plata Peak	14,336'	Sawatch	19.	Mt. Princeton	14,197'	Sawatch
6.	Uncompahgre Peak	14,309'	San Juan	20.	Crestone Needle	14,197'	Sangre de Cristo
7.	Crestone Peak	14,294'	Sangre de Cristo	21.	Mt. Yale	14,196'	Sawatch
8.	Mt. Lincoln	14,286'	Tenmile–Mosquito	22.	Mt. Bross	14,172'	Tenmile–Mosquito
9.	Grays Peak	14,270'	Front Range	23.	Kit Carson Peak	14,165'	Sangre de Cristo
10.	Mt. Antero	14,269'	Sawatch	**	El Diente Peak	14,159'	San Juan
11.	Torreys Peak	14,267'	Front Range	24.	Maroon Peak	14,156'	Elk
12.	Castle Peak	14,265'	Elk	25.	Tabeguache Peak	14,155'	Sawatch
13.	Quandary Peak	14,265'	Tenmile–Mosquito	26.	Mt. Oxford	14,153'	Sawatch
14.	Mt. Evans	14,264'	Front Range	27.	Mt. Sneffels	14,150'	San Juan
15.	Longs Peak	14,255'	Front Range	28.	Mt. Democrat	14,148'	Tenmile–Mosquito

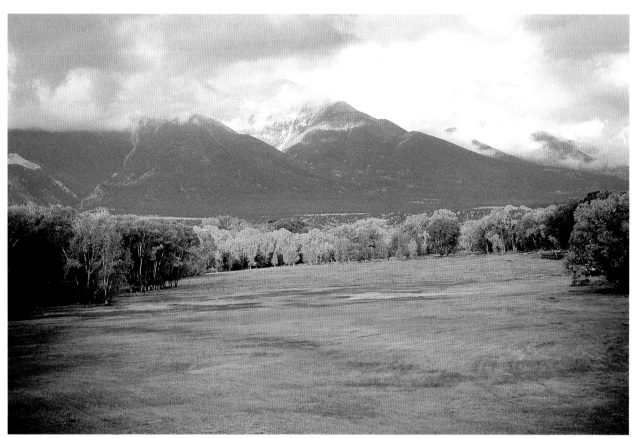

Mount Princeton in September

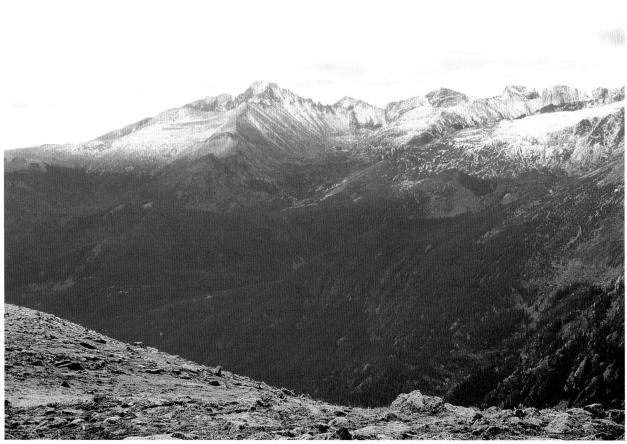

Longs Peak

Rank	Mountain	Elevation	Mountain Range
29.	Capitol Peak	14,130'	Elk
30.	Pikes Peak	14,110'	Front Range
31.	Snowmass Mtn.	14,092'	Elk
32.	Mt. Eolus	14,083'	San Juan
33.	Windom Peak	14,082'	San Juan
34.	Challenger Point	14,081'	Sangre de Cristo
35.	Mt. Columbia	14,073'	Sawatch
36.	Missouri Mountain	14,067'	Sawatch
37.	Humboldt Peak	14,064'	Sangre de Cristo
38.	Mt. Bierstadt	14,060'	Front Range
***	Conundrum Peak	14,060'	Elk
39.	Sunlight Peak	14,059'	San Juan
40.	Handies Peak	14,048'	San Juan
41.	Culebra Peak	14,047'	Sangre de Cristo

Rank	Mountain	Elevation	Mountain Range
42.	Ellingwood Point	14,042'	Sangre de Cristo
43.	Mt. Lindsey	14,042'	Sangre de Cristo
****	North Eolus	14,039'	San Juan
44.	Little Bear Peak	14,037'	Sangre de Cristo
45.	Mt. Sherman	14,036'	Tenmile–Mosquito
46.	Redcloud Peak	14,034'	San Juan
47.	Pyramid Peak	14,018'	Elk
48.	Wilson Peak	14,017'	San Juan
49.	Wetterhorn Peak	14,015'	San Juan
*****	North Maroon Peak	14,014'	Elk
50.	San Luis Peak	14,014'	San Juan
51.	Mt. of the Holy Cross	14,005'	Sawatch
52.	Huron Peak	14,003'	Sawatch
53.	Sunshine Peak	14,001'	San Juan

NOTE: For a mountain to be considered a fourteener, it must rise at least 300 feet above the saddle that connects it to the nearest fourteener, if another exists nearby. The following peaks are "unofficial" fourteeners because they do not fit this criterion, but they are named and recognized on U.S. Geological Survey (USGS) maps:

 Mt. Cameron—rises 138 feet above its connecting saddle with Mt. Lincoln.

 ***El Diente—rises 259 feet above its connecting saddle with Mt. Wilson.*

 ****Conundrum Peak—rises 240 feet above its connecting saddle with Castle Peak.*

 *****North Eolus—rises 179 feet above its connecting saddle with Mt. Eolus.*

 ******North Maroon Peak—rises 234 feet above its connecting saddle with Maroon Peak.*

Aspens and pines

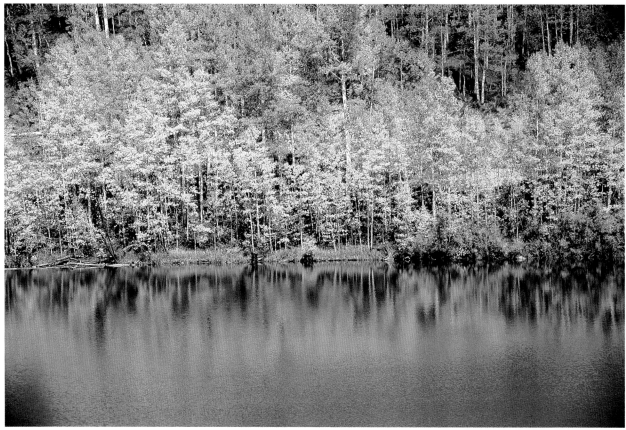

Aspens at Cushman Lake, near Telluride

MOUNTAIN VEGETATION:
Five Life Zones

ARCTIC LIFE ZONE: ALPINE TUNDRA

ELEVATION: Above 11,500 feet (approximate timberline)

LANDSCAPE: Rolling fields of small, loose, splintered rock; thin dry soil with dwarf shrubs and willow, sedge, and tufts of short wiry grass; boulders spotted with primitive plants such as lichens and moss; intense sun, extreme cold, and harsh drying winds of more than 100 miles per hour

WILDFLOWERS: Most profuse in July and August; magnificent carpets of tiny flowering plants such as arctic gentian, yellow paintbrush, alpine sunflower (*Rydbergia* spp.), Parry primrose, marsh marigold, dwarf clover, bistort, and phlox; very short growing season, often less than eight weeks, as stunted plants struggle to survive in a climate conspired against life. It is essential to prevent damage by hikers to this fragile vegetation, for trampled tundra may take many hundreds of years to recover. While these tiny survivors grow by the inch, they die by the foot.

Moisture: 30 to 55 inches annually, almost all from snow; perpetual snowfields, especially in shady areas

HUDSONIAN LIFE ZONE: SUBALPINE

ELEVATION: From 10,000 to 11,500 feet

LANDSCAPE: Woodlands; wet and dense evergreen forests of subalpine fir (soft flat needles and upright cones), Engelmann spruce (four-sided prickly needles and cones that hang downward), and Colorado blue spruce draped down mountainsides; stunted, twisted trees and the rare and near-extinct ancient bristlecone pine cling to the hostile rocky slopes at timberline; aspen grows at lower elevations (below 10,500 feet) in this zone

WILDFLOWERS: Lush growth from mid-June through August

MOISTURE: 25 to 40 inches annually, mostly from snow

CANADIAN LIFE ZONE: MONTANE

ELEVATION: From 8,000 to 10,000 feet

LANDSCAPE: Immense aspen forests, often with an undergrowth of shrubs such as snowberry, currant, and elderberry; Colorado blue spruce, willow thickets, and alder in moist glades; large stands of ponderosa and lodgepole pine (which colonize distressed forests) on sunny south-facing hillsides at lower elevations, with scattered Douglas fir on cooler north-facing slopes

WILDFLOWERS: Moderate to lush growth from June through August

MOISTURE: 18 to 30 inches annually, at least half from snow

TRANSITION LIFE ZONE: FOOTHILLS AND MESAS

ELEVATION: From 6,500 to 8,000 feet

LANDSCAPE: Forests of pinyon pine, juniper, and Gambel oak, with pockets of Douglas fir; shrubs such as serviceberry, mountain mahogany, and snowberry; ponderosa pine at higher elevations

WILDFLOWERS: Moderate to good wildflower growth in May and June

MOISTURE: 14 to 25 inches annually, about half from snow

UPPER SONORAN OR PLAINS LIFE ZONE: SEMI-DESERTS AND CANYONS

ELEVATION: From 5,000 to 6,500 feet

SEMI-DESERT LANDSCAPE: Arid, barren, sandy flats with shrubs of saltbush and sagebrush; pinyon pine and juniper woodlands, tamarisk, and willow with cottonwood along streams and washes

CANYON LANDSCAPE: Rocky cliffs with pinyon pine, juniper, and oak; thick patches of yucca, sagebrush, mountain mahogany, and other shrubs

WILDFLOWERS: Growth is best from March to June, but is highly dependent on winter moisture

MOISTURE: 7 to 14 inches annually, one-fourth or less from snow

Aspens

TRAVELING
the Colorado Rockies

TRAVELING MAP:

Dinosaur National Monument
Craig
Steamboat Springs
Cameron Pass
Rocky Mountain National Park
287
25
to Ft Morgan
85
Ft Collins
Greeley
76
Dinosaur
40
Trappers Lake
40
Estes Park
Loveland
Lyons
Berthoud Pass
Grand Lake
Boulder
Nederland
Golden
Denver International Airport
N
Glenwood Springs
Glenwood Canyon
Vail
Loveland Pass
Idaho Springs
Denver
Rifle
Eagle
Frisco
Mt Evans
470
70
Grand Junction
Aspen
Breckenridge
24
285
70
Fruita
Maroon Bells
Independence Pass
24
Florissant Fossil Beds
Air Force Academy
24
to Limon
Colorado National Monument
GRAND MESA
Black Canyon National Park
Divide
National Monument
Pikes Peak
Colorado Springs
94
to Limon
50
Tabeguache BW
Gunnison
Salida
50
Unaweep
Montrose
Curecanti National Recreation Area
Monarch Pass
Canon City
Pueblo
141
550
17
Norwood
Ridgway
285
Great Sand Dunes National Park
Telluride
Ouray
Continental
Silverton
25
141
491
San Juan Skyway
160
17
Walsenburg
160
160
Wolf Creek Pass
Alamosa
Cortez
Mancos
Pagosa Springs
160
Kilometers
Miles
locations and distances are approximate
160
491
Durango
160
285
Mesa Verde National Park
Four Corners Monument

LEGEND

National Park	National Monument	Wilderness Area	Entrance / Visitor Center	Metro Area
National Forest	Nat'l Recreation Area	State / City Park	Overlook / Point of Interest	City / Town
River/Lake	National Preserve	Mountain Pass	Photo Location -	Mountain Peak
89 Highway	70 Interstate	Continental Divide		

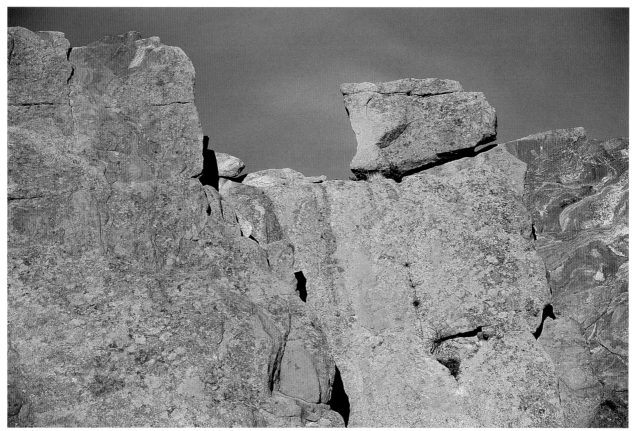

Sandstone of the Lyons and Fountain formations in Garden of the Gods, Colorado Springs

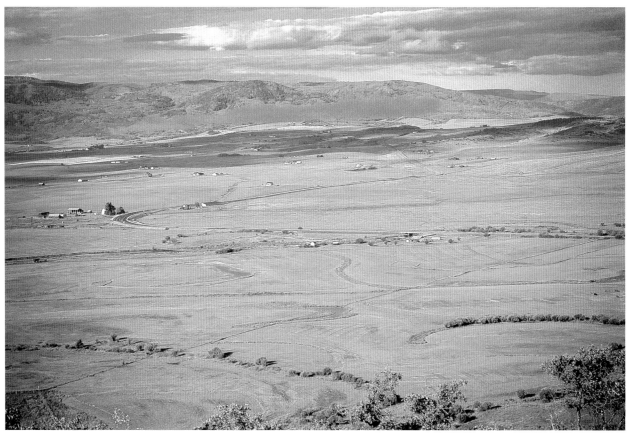

Near Steamboat Springs

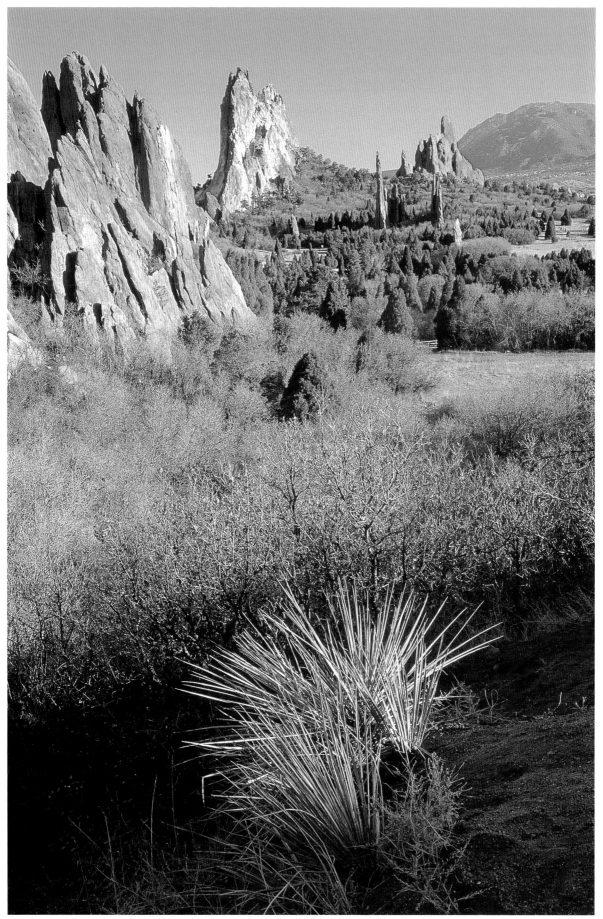

Garden of the Gods in Colorado Springs

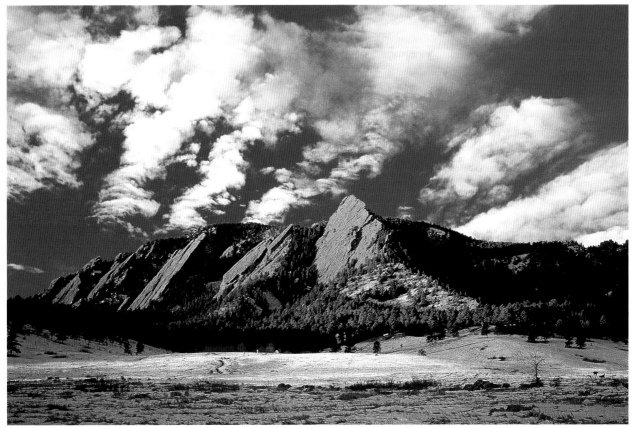

The Flatirons, Fountain formation sedimentary deposits along mountain flanks west of Boulder

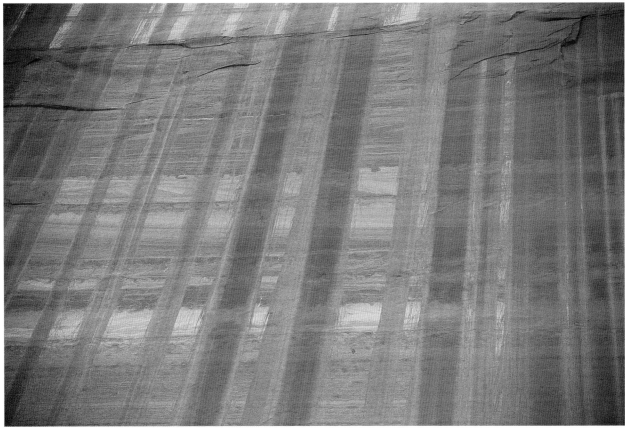

Desert varnish at Mile Marker 83 on CO 141

Cross-bedded sandstone on the Colorado Plateau

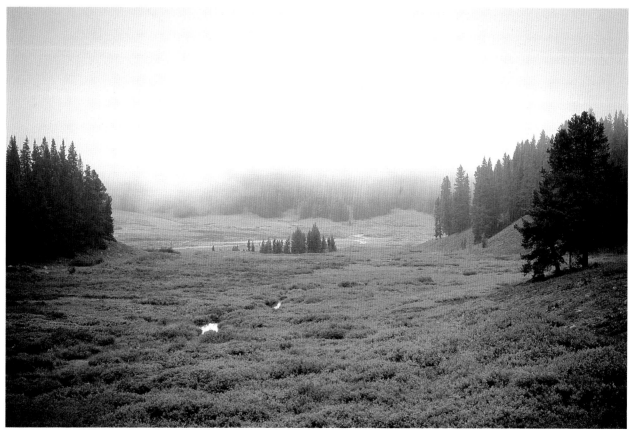

Descending cloud

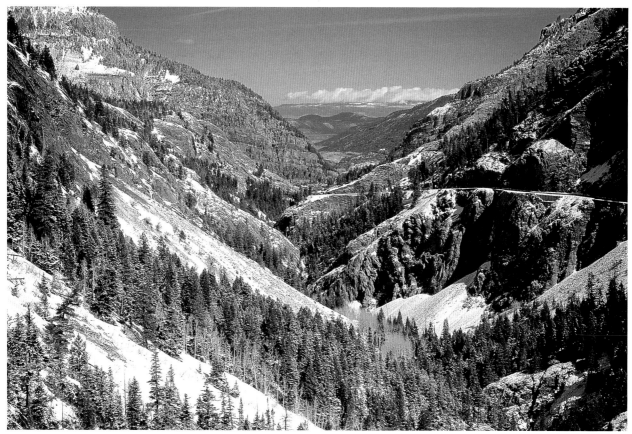

The Million Dollar Highway through the Uncompahgre Gorge

General Precautions

AVALANCHES

Open slopes of thirty to forty-five degrees may be loaded with precarious masses of dangerous heavy snow, and easily triggered to avalanche by the mere presence of a person. Active avalanche paths are usually grass-covered only, having been swept clean of trees and shrubs by tons of plummeting snow.

CLIMATE

HEAT: Blistering summer temperatures in the southern lowlands can exceed one hundred degrees Fahrenheit, and sometimes there is no protective shade; summer nights can dip below freezing at higher elevations.

DRYNESS: Humidity can drop below 10 percent in the barren desert regions near the Four Corners.

WIND: The powerful erosive force of constant wind can irritate skin, eyes, and lungs, and destroy photography equipment.

SUN: Brilliant and strong, so skin, lips, nose, and eyes need protection year-round. The sun's ultraviolet rays increase in intensity about 5 percent for every gain of 1,000 feet in elevation.

CLOTHING

Dress in layers and wear sturdy shoes with good tread. Cotton should not be worn during strenuous cold-weather activities because it absorbs water and dries slowly, causing rapid loss of body heat.

DANGEROUS CREATURES

Be aware that some hiking areas are inhabited by mountain lions. Back away slowly, but above all, *do not run*. Demonstrate that you are a danger, not prey. If the animal does not retreat, try to appear large, make noise, throw stones, and fight back if it attacks. Ticks, which are abundant in the spring and summer, may carry diseases such as Colorado tick fever and Rocky Mountain spotted fever, both life threatening. Contact with diseased or poisonous animals, insects, and plants requires immediate medical attention.

DEHYDRATION

A minimum of two quarts of water per person per day is recommended for normal activity. Do not drink springwater or stream water—no matter how pure it appears—unless it has been boiled for at least five minutes to destroy *Giardia lamblia* bacteria.

DRIVING AT HIGH ALTITUDE

Obey the speed limit. Know your vehicle well and understand its limitations. When driving in the mountains, keep the car in low gear with the air-conditioning off at all times, for both the ascent and the descent will strain the braking system and may overheat or vapor lock the engine. If this happens, put snow or cold water on the fuel pump or fuel line. Uphill drivers have the right-of-way to prevent them from having to drive downhill in reverse. Gas stations are few and far between in remote mountain areas.

Here is a series of road signs along east I–70 that warn of the dangers of descending too fast from the Front Range into Denver:

STEEP DOWN GRADE AND SHARP CURVES 1 MILE AHEAD . . . <u>TRUCKERS</u> DON'T BE FOOLED—4 MORE MILES OF STEEP GRADES AND SHARP CURVES . . . WINDING 6% GRADE—STAY GEARED DOWN NEXT 3 MILES . . . RUNAWAY TRUCK RAMP RIGHT ¾ MILE . . . TRUCKERS YOU ARE NOT DOWN YET—ANOTHER 1½ MILES OF STEEP GRADES AND SHARP CURVES TO GO.

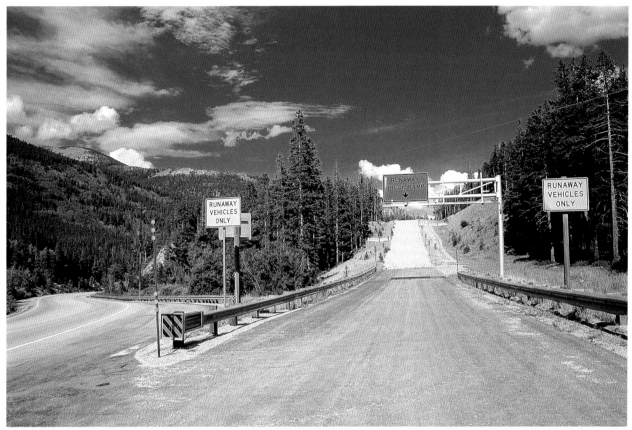

Runaway truck ramp on Monarch Pass

Hayman Fire destruction in Pike National Forest

HIGH ALTITUDE AND HEALTH

Each breath at 14,000 feet contains effectively 40 percent less oxygen than at sea level. The ascent of high peaks is discouraged for infants and individuals with cardiac or respiratory conditions. Altitude sickness, especially at elevations above 8,000 feet, can cause headaches, nausea, swelling, insomnia, rapid heart rate, and shortness of breath. Rest, noncaffeinated fluids, carbohydrates, and descent to lower altitude will bring some relief. For every gain of 1,000 feet in elevation, the temperature will drop approximately four degrees Fahrenheit, the equivalent of traveling north about 600 miles. It is typically fifty degrees colder at the summit of the fourteeners than at the base. Dress accordingly. Wind speeds of 200 miles per hour have been recorded on some summits.

HYPOTHERMIA

Hypothermia (low body temperature) is the result of rapid loss of core body heat, which is serious and can be fatal. Initial symptoms include shivering, confusion, slurred speech, and stumbling. As hypothermia progresses, symptoms include extreme drowsiness, decreased pulse and respiration, cessation of shivering, and finally collapse. Hypothermia must always be considered a medical emergency. Remove the victim from cold and wind as quickly as possible, change out of wet and into warm dry clothing, cover the head and neck, and give warm, sweet food and drink. Seek medical help immediately. In the meantime, warm the victim inside a sleeping bag with another person.

REMOTENESS

Do not hike alone, and always inform a park ranger (or another authority if you are outside park boundaries) of your itinerary. If you become lost, stay where you are. Cellular and wireless phones are often useless here, for there may be no existing communications cells.

RULES AND REGULATIONS

Obey and respect all posted or published park regulations and recommendations. Never feed animals, disturb wildlife, or remove rocks, wood, plants, artifacts, *anything*. Stay on marked trails only; do not walk on soil or fragile alpine and tundra vegetation. Take only pictures and leave no trace of your presence.

SERVICES

Park services may be limited from October through May and strained under the press of tourist crowds during the summer. Gasoline stations, medical services, and food and water stops are few and far between in remote areas.

UNSTABLE GROUND

Weathered rock on cliff edges can break off without warning, especially near sheer drop-offs.

WEATHER

Weather in Colorado's high country can change quickly, dramatically, and without warning. Sudden thunderstorms can trigger deadly lightning and flash floods throughout the mountains and canyons. Do not enter *any* canyon or streambed if the skies are ominous or the threat of rain exists.

WILDFIRE

Open fires are not advised, especially above timberline. Use a camp stove for cooking. One mistake with a spark or flame can destroy thousands of acres of forest.

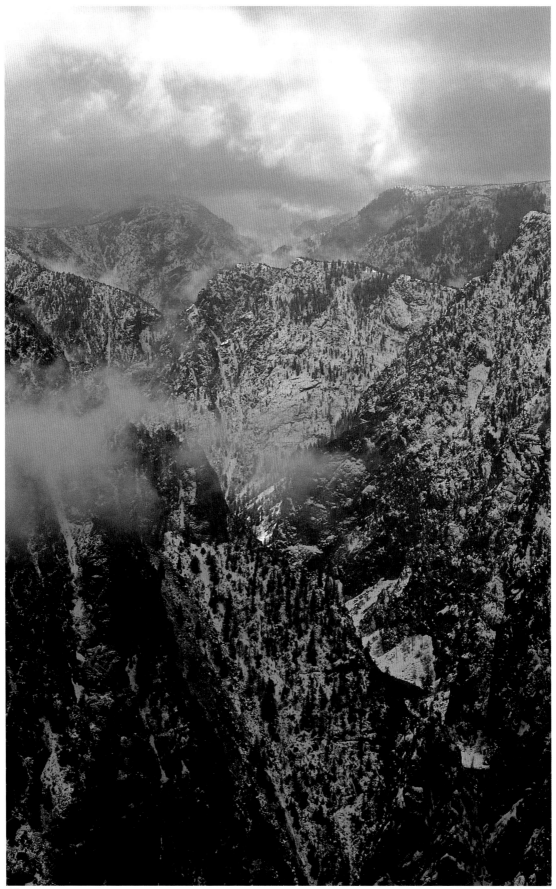

① *Tomichi Point*

BLACK CANYON

of the Gunnison National Park (South Rim)

LOCATION: Northeast of Montrose, Colorado

ELEVATION: Ranges from 6,547 feet at East Portal to 8,289 feet at High Point

NAME: While exploring the area in search of a transcontinental railroad route in 1853, army captain John W. Gunnison and his survey party were halted by the impossibility of spanning Black Canyon.

AREA MAP:

GEOGRAPHY: The forbidding Black Canyon, nearly impenetrable by sunlight, is a precipitous narrow gash in the Gunnison Uplift, 48 miles long and often as deep as 2,600 feet. It is split by the unleashed force of the churning Gunnison River, filled with immense boulders and bound by sheer dark gray walls carved from granite, schist, gneiss, and other Precambrian rock more than 1.5 billion years old. Because the domed Gunnison Uplift is harder and higher than the surrounding terrain, the Gunnison River has no major tributaries within Black Canyon. Water either cuts straight down or flows away from the elevated riverbed. Nor has the downcutting leveled its course through erosion—here in Black Canyon the Gunnison River is deeper for its width

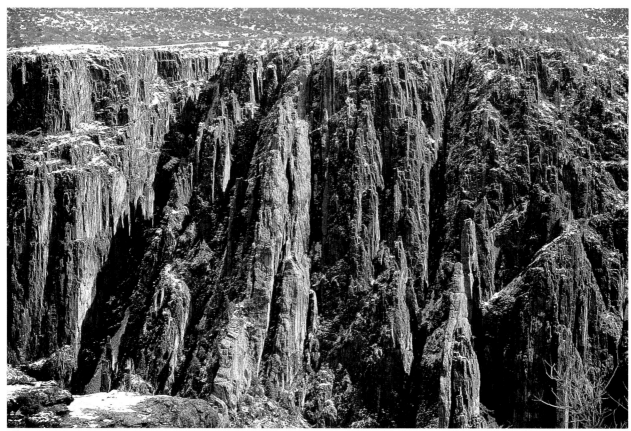

2 *The North Wall from Gunnison Point*

Pines

than any other river in North America and has the greatest rate of fall, an incredible 480 feet in the 2 miles between Pulpit Rock and Chasm View. The scene is softened by colorful lichens that spot and tinge the somber, jagged cliffs and have contributed in a minor way to the formation of the canyon by producing an acid that gradually weakens the stone, making it more susceptible to erosion. The deepest and most spectacular 12-mile middle section of Black Canyon was designated a National Monument in 1933 and then a National Park in 1999.

LOCAL MAP: The entrance to the South Rim of Black Canyon National Park is on CO 347, which heads north for 5 miles off US 50, about 8 miles east of Montrose.

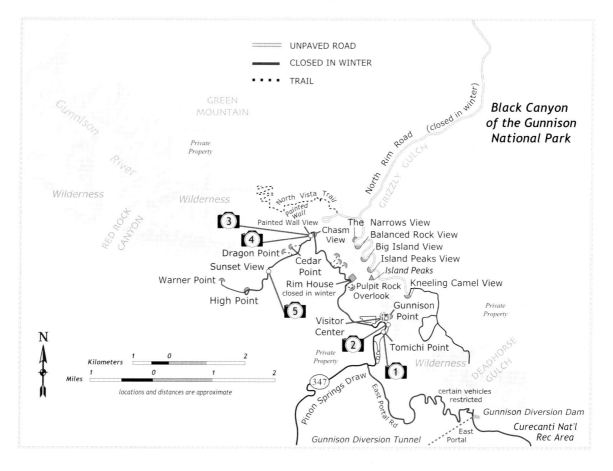

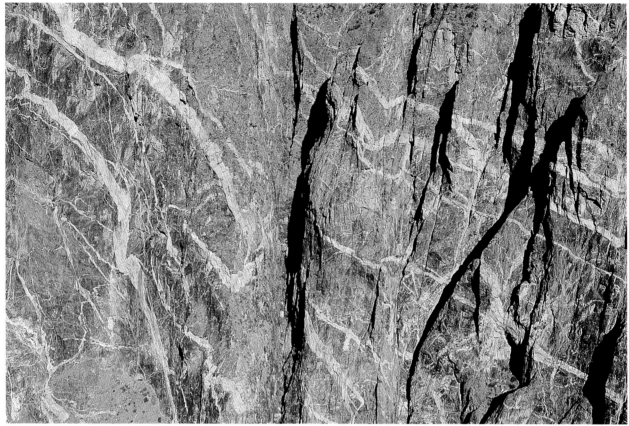

3 *The Painted Wall 9:00* A.M.

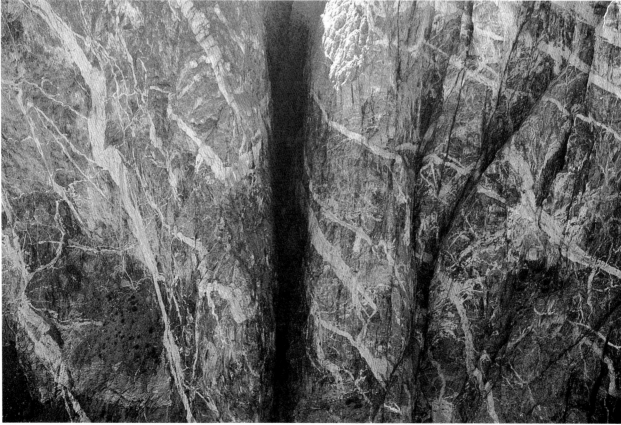

4 *The Painted Wall 4:00* P.M.

SUGGESTED LENGTH OF STAY: 1 to 2 days

BEST TIME TO BE THERE: Midday in soft, diffuse light; otherwise at dawn or dusk when the sun drops into the canyon. Photographing Black Canyon is a challenge in full direct sun because of the extreme range of brightness from river to rim. The northeast-facing overlooks between the visitor center and Chasm View are more beautiful in the late afternoon, while the northwest-facing overlooks toward the end of the park are best in morning light.

HIGHLIGHTS:

- **Chasm View** is without a doubt the park's most breathtaking overlook. High and airy, the cliffs drop away from the rim and plunge into darkness to the river 1,800 feet below. The geology is raw and inaccessible—shadowy side canyons, sweeps of upturned rock, jutting buttresses, and countless abrupt ledges and gullies.

- **The Narrows** demonstrates Black Canyon at its most extreme proportions. Here the canyon's depth of 1,700 feet far exceeds its rim-to-rim distance as it closes to a crack just 40 feet wide at river level.

- **The Painted Wall,** a sheer rise of 2,240 feet, is the highest cliff in Colorado. It can be seen best from Painted Wall View or Dragon Point. The dark granite cliffs are marbled in beautiful spidery patterns with bands of light gray, pink, and brown pegmatite (igneous intrusions), the result of magma being forced under tremendous pressure into the joints, cracks, and fissures of the harder crystalline base rock. This network of pegmatite dikes strengthens the cliff face and allows the Painted Wall to stand as a solid vertical slice into ancient stone. Lit directly by morning light and falling into soft shadow in the afternoon, its massive form is transformed completely by the angle and strength of the sun.

- **Warner Point** is the deepest point in the gorge, at 2,772 feet.

- At a point about 2 miles north of US 50 on CO 347, the shadowy giants of the **Sneffels Range** can be seen stretched out along the southern horizon. (See San Juan Skyway.)

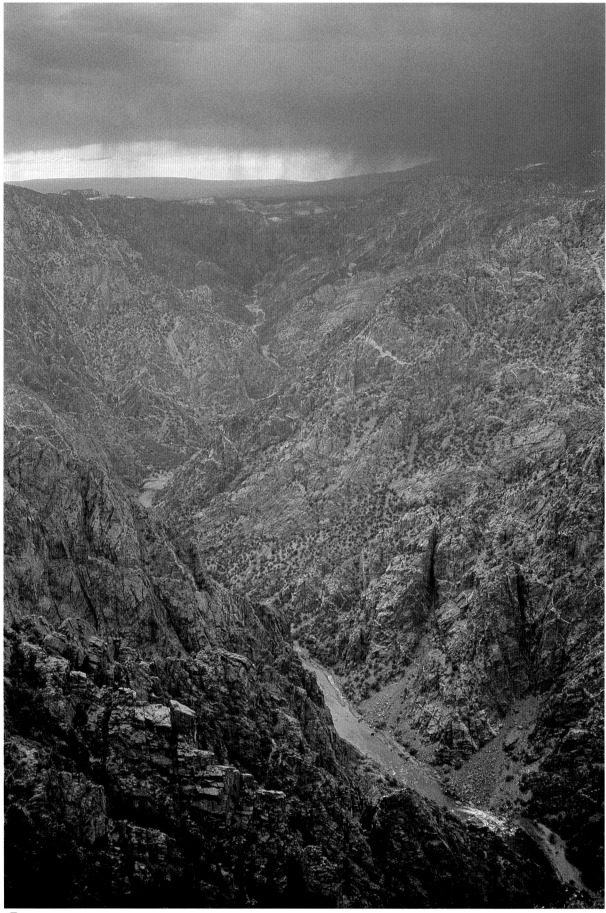

5 *Evening at Sunset View*

• Sharing its western boundary with Black Canyon National Park is the sprawling **Curecanti National Recreation Area,** a maze of deep, narrow canyons and broad mesas surrounding three reservoirs named for the corresponding dams on the Gunnison River, which form its heart. Morrow Point Reservoir marks the beginning of Black Canyon of the Gunnison. Crystal Reservoir is the site of the Gunnison Diversion Tunnel, a National Historic Civil Engineering Landmark. And Blue Mesa Reservoir, Colorado's largest body of water, is also the largest kokanee salmon fishery in the United States. Of the three, Blue Mesa Reservoir provides the greatest variety of outdoor recreational opportunities, including boating, camping, hiking, fishing, and snowmobiling. For more information: Curecanti National Recreation Area, 102 Elk Creek, Gunnison, CO; (970) 641–2337.

LOCAL MAP:

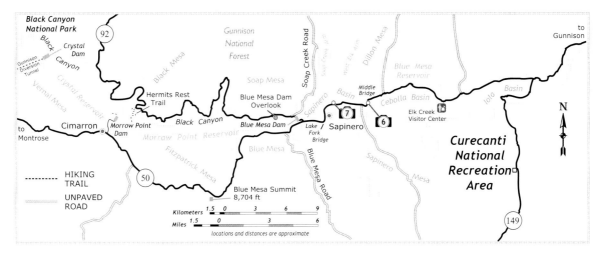

COLORFUL COMMENTS

"WE HAD BEEN CLIMBING FOR VERY MANY HOURS WHEN WE ENTERED A GORGE, REMOTE FROM THE SUN, WHERE THE ROCKS WERE TWO THOUSAND FEET SHEER AND WHERE A ROCK-SPLINTERED RIVER ROARED AND HOWLED. THERE WAS A GLORY AND WONDER AND A MYSTERY ABOUT THAT MAD RIDE WHICH I FELT KEENLY. WE SEEMED TO BE RUNNING INTO THE BOWELS OF THE EARTH AT THE INVITATION OF AN IRRESPONSIBLE STREAM."

——RUDYARD KIPLING, 1889

27

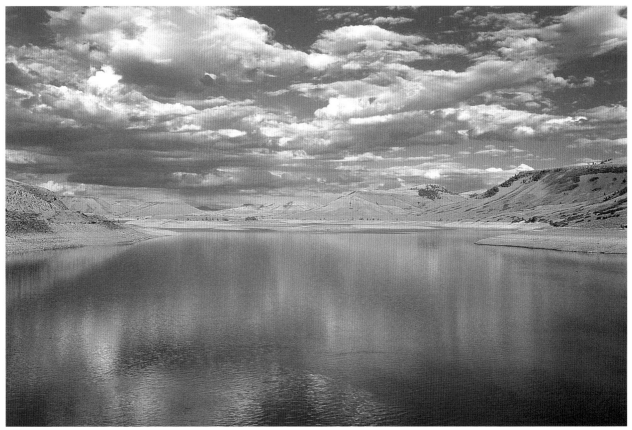

6 *Blue Mesa Reservoir*

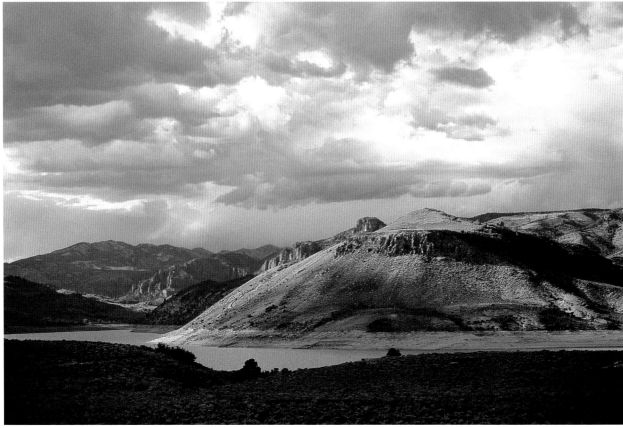

7 *Blue Mesa Reservoir/Lake Fork*

"OUR SURROUNDINGS WERE OF THE WILDEST POSSIBLE DESCRIPTION. THE ROAR OF THE WATER . . . WAS CONSTANTLY IN OUR EARS, AND THE WALLS OF THE CANYON, TOWERING HALF MILE IN HEIGHT ABOVE US, WERE SEEMINGLY VERTICAL. OCCASIONALLY A ROCK WOULD FALL FROM ONE SIDE OR THE OTHER, WITH A ROAR AND CRASH, EXPLODING LIKE A TON OF DYNAMITE WHEN IT STRUCK BOTTOM, MAKING US THINK OUR LAST DAY HAD COME."

—ABRAHAM LINCOLN FELLOWS, 1901

GENERAL INFORMATION

FEE:	Yes	CONVENIENCE STORE:	No
VISITOR CENTER:	Yes	HIKING:	Yes
4WD NEEDED:	No	CAMPING:	Yes
GAS WITHIN 5 MILES:	No	LODGING WITHIN 5 MILES:	No
RESTROOMS:	Yes	PHOTO RATING (1–5):	3.5
FOOD/WATER:	Yes	CHILD RATING (1–5):	2

CAUTION: Descent into Black Canyon is dangerous and extremely difficult, and should be attempted only by experienced climbers. Do not venture off the trails without consulting a park ranger, because backcountry permits are required for hiking in the park. Even the smallest pebble thrown from the rim into the canyon can be fatal to someone below. In the winter the South Rim Drive is open only as far as the Gunnison Point Visitor Center, and closed completely after heavy snowfall.

FOR MORE INFORMATION

Superintendent, Black Canyon of the Gunnison National Park
102 Elk Creek, Gunnison, CO 81230
(970) 641–2337
www.nps.gov/blca

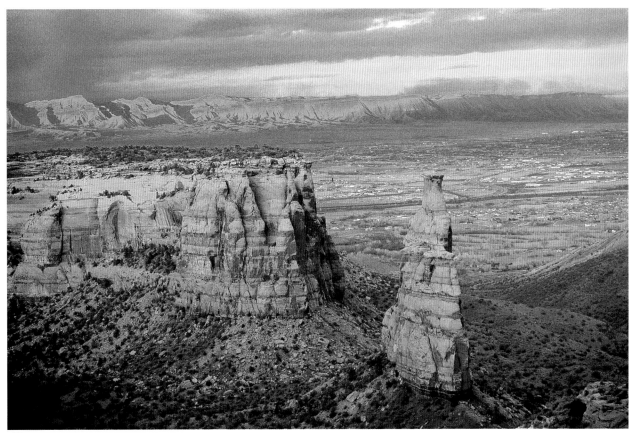

8 *Independence Monument*

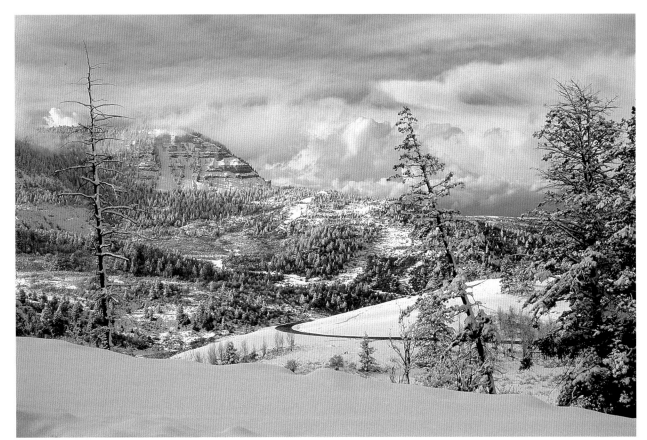

9 *Douglas Pass, north of Colorado National Monument*

COLORADO
National Monument

LOCATION: Between Grand Junction and Fruita, Colorado

ELEVATION: Ranges from 4,690 feet at the Fruita entrance to 6,640 feet on Rim Rock Drive between Fallen Rock Overlook and Ute Canyon View

SPANISH NAME: *Colorado*—"colored red"

UTE NAME: *Uncompahgre*—"hot water spring;" "the place with red water"

LOCAL MAP: The entrances to Colorado National Monument are near Grand Junction off Monument Road and near Fruita along CO 340, the Redlands Highway.

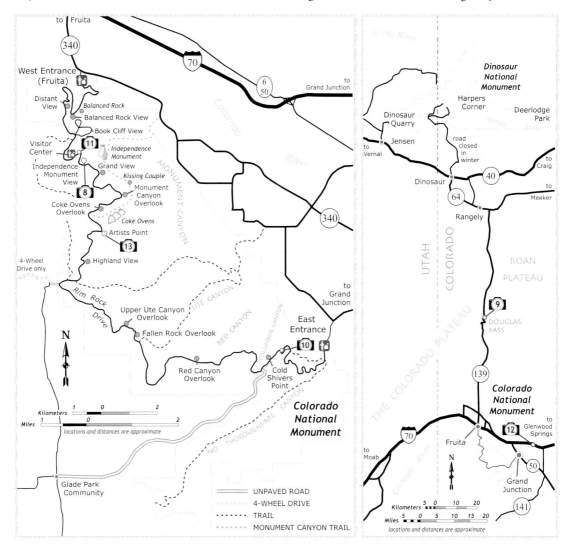

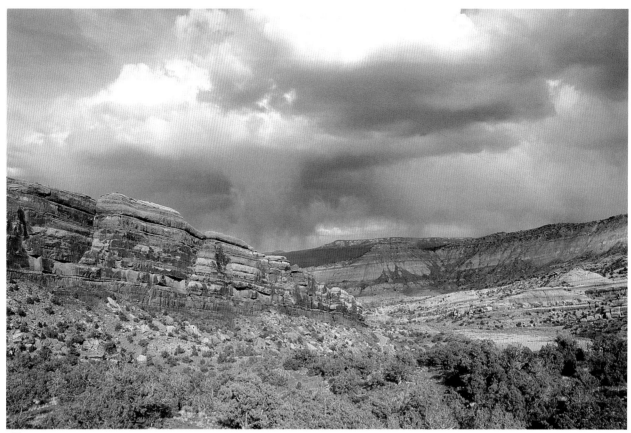

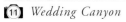 *Uncompahgre Uplift*

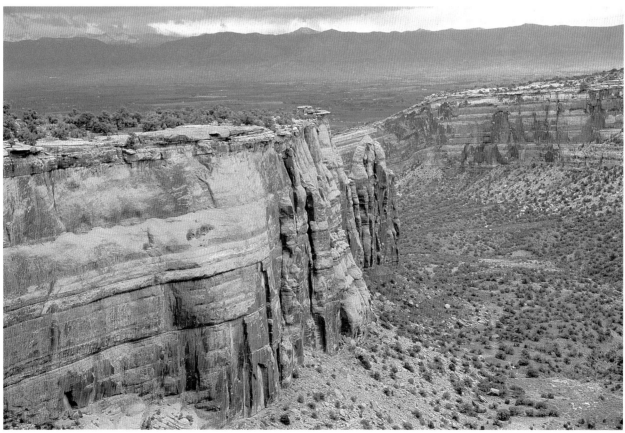

11 *Wedding Canyon*

GEOGRAPHY: Colorado National Monument lies on the Uncompahgre Uplift, along the northern edge of a high mesa that water and wind have carved into a series of solitary sandstone monoliths deep within sheer-walled canyons. It is lush and brilliant with color—deep reds and flaming orange, pale browns, white, and cool purple. Everywhere the rock is punctuated with bursts of green Utah juniper and pinyon pine, which cover the mesa and fill the Grand Valley of the Colorado River 2,000 feet below.

SUGGESTED LENGTH OF STAY: 1 day

BEST TIME TO BE THERE: Sunrise, all year-round

HIGHLIGHTS:

- **Rim Rock Drive** winds along the edge of the mesa for 23 miles between Fruita and Grand Junction. The northwestern third of the drive near Fruita is the most dramatic, for here the road narrows and skirts the canyons' edges, twisting and doubling back on itself in one hairpin turn after another. After Artists Point a distinct shift from red to white occurs in the color of the sandstone as you enter the middle third, higher and broader, with far fewer overlooks visible from the road. Red rock begins to appear again in the southeastern end of the park as the descent to Grand Junction begins. Here the sandstone layers are clearly exposed, with strong bands of color appearing in the jumbled and fractured rock strata thrust upward at all angles.

- **Independence Monument** is a slender and freestanding 450-foot tower of Wingate sandstone rising from rock-strewn slopes of Chinle formation. At the very top is a thin layer of harder Kayenta sandstone, which forms a protective cap, preserving this remnant of a once massive rock wall that stood between Monument and Wedding Canyons.

- **Monument Canyon Overlook** (northwest pullout) offers the best views of the Colorado River Valley, the white shale Book Cliffs, and the enormous flat-topped Grand Mesa, visible in the distance.

- **The Coke Ovens,** a row of Wingate sandstone domes, resemble actual coke ovens.

- **Cold Shivers Point,** atop vertical cliffs, overlooks Columbus Canyon and the Grand Valley.

- About 3 miles from the Grand Junction entrance, the magnificent and bold colors of the **Uncompahgre Uplift,** a giant striated rock table, rise up in all directions around Rim Rock Drive.

12 *The Book Cliffs*

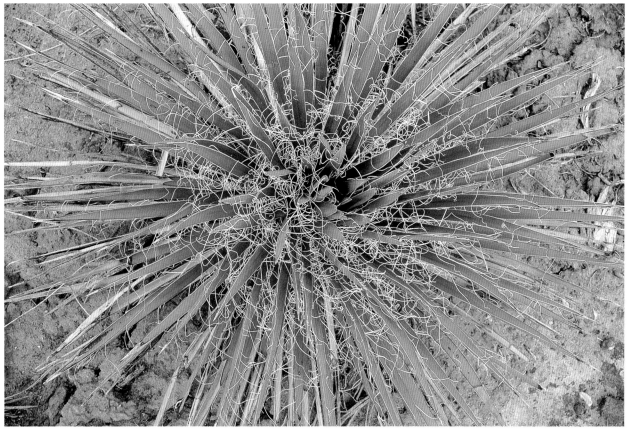

13 *Yucca, sometimes called Spanish bayonet*

- Throughout the park are numerous short trails and backcountry hikes ranging from 0.25 mile to 8.5 miles, from easy to strenuous. Consult the official map and guide for details about the fourteen most recommended, including the popular 6-mile Monument Canyon Trail to the base of Independence Monument, Kissing Couple, and the Coke Ovens.

COLORFUL NOTE

Just to the east of Grand Junction and visible from Rim Rock Drive lies the sprawling Grand Mesa, believed to be the world's largest and highest flat-topped mountain at 564 square miles and more than 10,000 feet in elevation.

GENERAL INFORMATION

FEE:	Yes	CONVENIENCE STORE:	No
VISITOR CENTER:	Yes	HIKING:	Yes
4WD NEEDED:	No	CAMPING:	Yes
GAS WITHIN 5 MILES:	Yes	LODGING WITHIN 5 MILES:	Yes
RESTROOMS:	Yes	PHOTO RATING (1–5):	3
FOOD/WATER:	No	CHILD RATING (1–5):	2

FOR MORE INFORMATION

Superintendent
Colorado National Monument
Fruita, CO 81521-0001
(970) 858–3617
www.nps.gov/colm

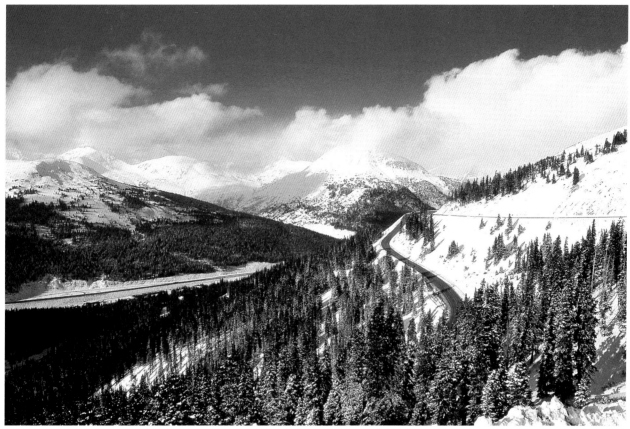

14 *Loveland Pass*

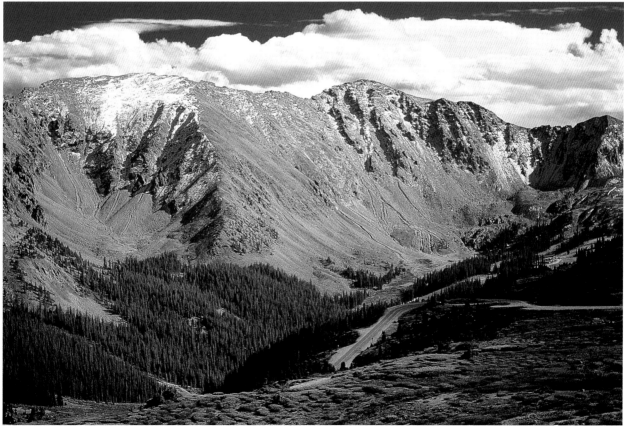

15 *Loveland Pass summit*

THE CONTINENTAL
Divide

LOCATION: Within Colorado, the Continental Divide zigzags in a north–south line following the crest of the Rocky Mountains

ELEVATION: The highest paved point on the Continental Divide is 12,095 feet on Independence Pass, just west of Mount Elbert, Colorado's tallest mountain at 14,433 feet. Grays Peak (14,270 feet) in the Front Range is the highest geographic point.

GEOGRAPHY: The Continental Divide is an idea, a concept all about water and which way it flows. Extending like a backbone from Alaska almost to Tierra del Fuego (Cape Horn), it is where waters part, running down one slope or the other into either the Atlantic or the Pacific watersheds. In the United States, the Continental Divide reaches its highest elevations in Colorado where, except for just a few miles, it runs entirely within the wild and mountainous backcountry of national forests or Rocky Mountain National Park. It is, quite simply, one long and twisting extreme of geography—a rise of peaks, a jagged ridge, a broken line of battlements, a broad sloping meadow, a creator of weather, and a formidable barrier to travel.

BEST TIME TO BE THERE: Summer

HIGHLIGHTS:

- **Loveland Pass** (11,992 feet), just west of Denver between Silver Plume and Dillon, is an easy climb on US 6 (Exit 216 off I–70), which bypasses the Eisenhower Tunnel. From the east heading west, the ascent to the summit is short but steep, taking just a few miles. When approaching from the west, the rise is much longer and far more gradual, passing Keystone and Arapahoe Basin Ski Areas.

- **Monarch Pass** (11,312 feet) runs east–west on US 50 between Poncha Springs and Gunnison.

- **Wolf Creek Pass** (10,850 feet) runs northeast–southwest on US 160 between South Fork and Pagosa Springs.

Dillon Reservoir

Dillon Reservoir

AREA MAP:

The Continental Divide

Cache la Poudre River

Cameron Pass (24)

Milner Pass

Fort Collins

Yampa River

Big Thompson River

Estes Park

Steamboat Springs

Rocky Mountain National Park

Longs Peak

Boulder

White River

Berthoud Pass (23)

Mt Evans

River

Idaho Springs

Loveland Pass (14) (15)

Mt Bierstadt

Denver

Colorado River

Grays Peak

Breckenridge

Divide

MAROON BELLS

Aspen

Mt Massive

(17) (18)

Leadville

Mt Elbert

GRAND MESA

(20) (16)

(19) Independence Pass

Collegiate Peaks

Pikes Peak

Colorado Springs

Black Canyon of the Gunnison National Park

Curecanti National Recreation Area

Gunnison

Arkansas

River

Monarch Pass (21)

Pueblo

Gunnison River

Ouray

Continental

Silverton

Great Sand Dunes National Park

Stony Pass

Wolf Creek Pass (22)

N

Durango

Animas River

Kilometers 20 0 40

Miles 20 0 20 40

locations and distances are approximate

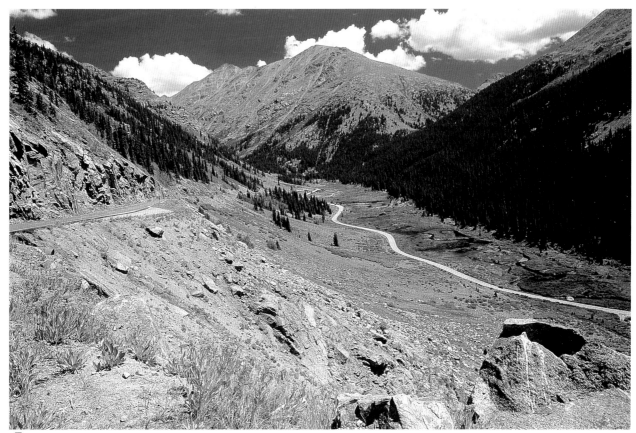

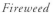 *Mount Champion (13,646 feet) and Lake Creek, along Independence Pass*

Fireweed

- **Independence Pass** (12,095 feet) is named for the frontier ghost town of Independence, 2 miles west of the summit, where gold was discovered on Independence Day, 1879. It is the highest paved mountain pass in the United States and by far the most dramatic of those that cross the Continental Divide. The pass itself tops a glorious 44-mile stretch of CO 82 that runs east–west across the Sawatch Range between Aspen and Leadville, two towns with important mining and cultural histories. The approach to the pass is long and winding from either direction, through verdant damp valleys threaded with creeks, up and over long sloping meadows, and around dense forests of pine and aspen. But when breaking through timberline into tundra, the spin to the summit is sudden.

- **Berthoud Pass** (11,307 feet) runs north–south on US 40 between Granby and Georgetown.

- **Milner Pass** (10,758 feet): See Rocky Mountain National Park.

COLORFUL NOTE

The Continental Divide National Scenic Trail follows the peaks of the Continental Divide, and 740 spectacular miles of it are here in Colorado's wild and tough backcountry, where the trail reaches a high point of 14,230 feet.

GENERAL INFORMATION

FEE:	No	CONVENIENCE STORE:	✳
VISITOR CENTER:	No	HIKING:	Yes
4WD NEEDED:	No	CAMPING:	Yes
GAS WITHIN 5 MILES:	✳	LODGING WITHIN 5 MILES:	✳
RESTROOMS:	No	PHOTO RATING (1–5):	4
FOOD/WATER:	✳	CHILD RATING (1–5):	3

✳ In towns along the way

CAUTION: Although heavily plowed, high mountain passes are often snowpacked or impassable in winter. Vehicles more than 35 feet long are prohibited on Independence Pass, which is closed from October to May.

FOR MORE INFORMATION

www.cdtrail.org

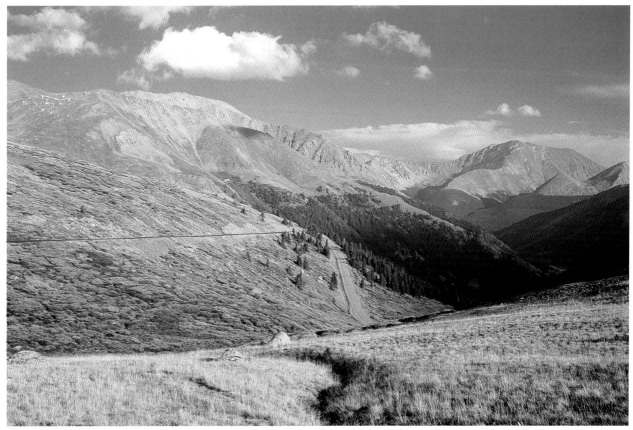

17 *La Plata Peak above Mountain Boy Gulch, near the Independence Pass summit*

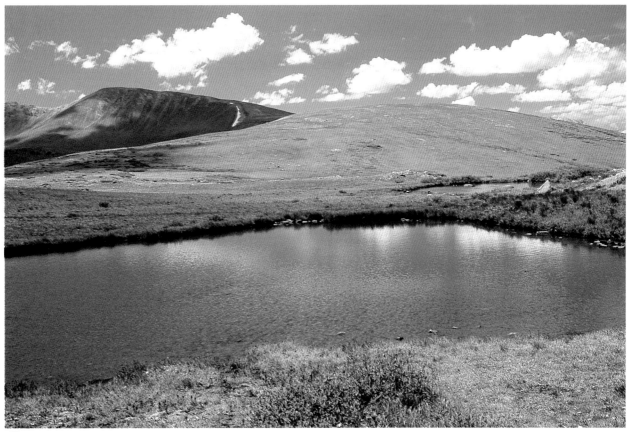

18 *Tundra pools on the Independence Pass summit*

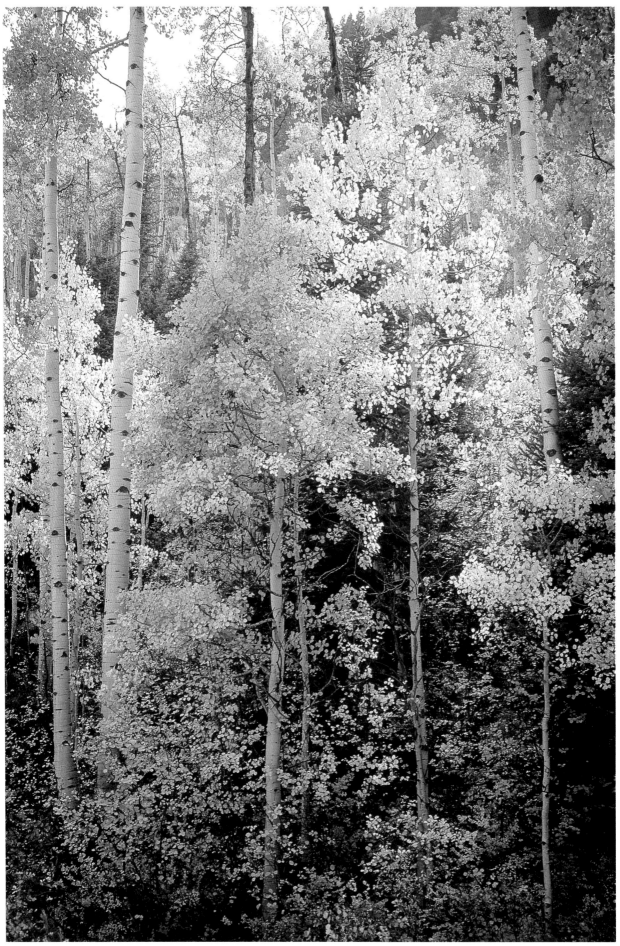

Aspens

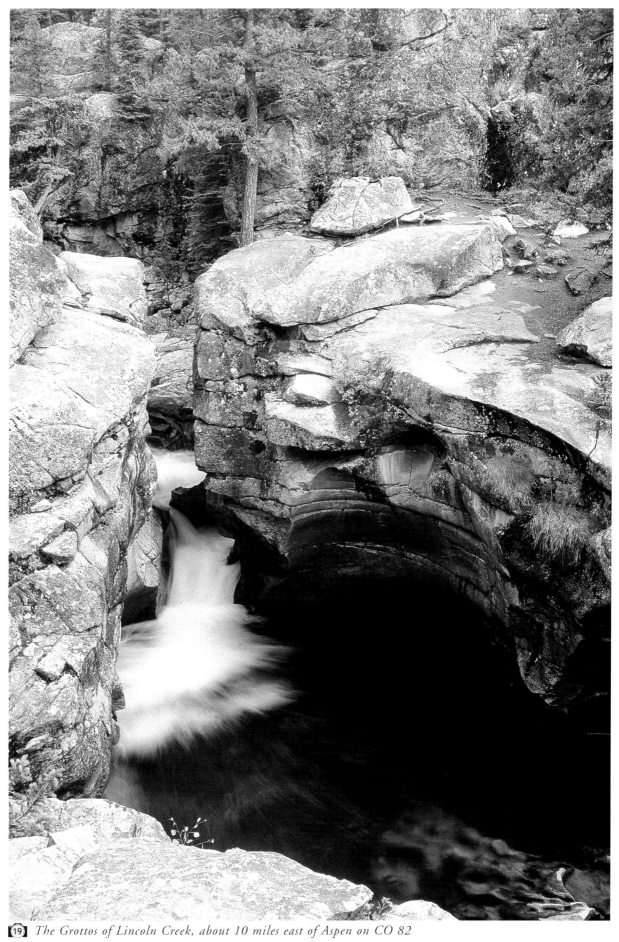

19 *The Grottos of Lincoln Creek, about 10 miles east of Aspen on CO 82*

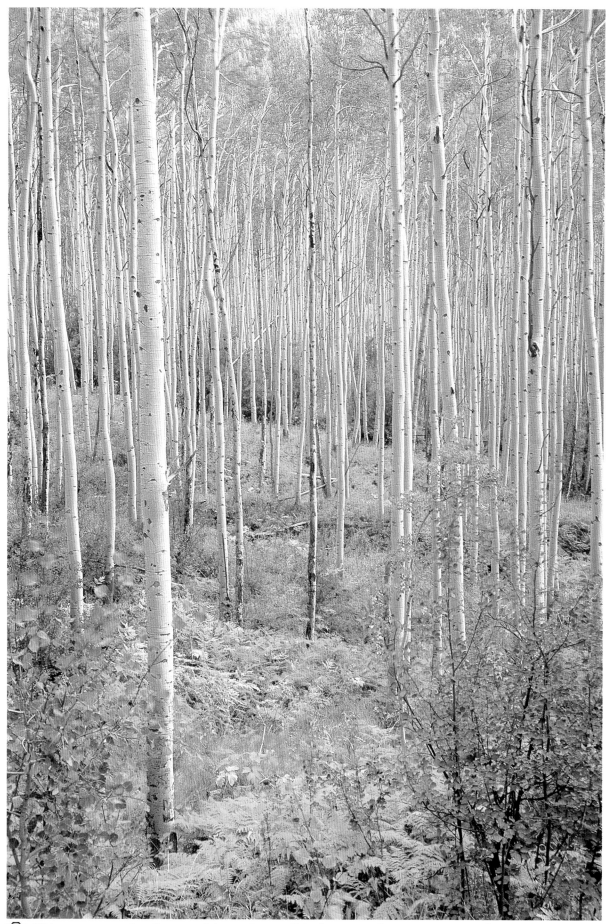

20 *This aspen grove, 8 miles east of Aspen, is one of the largest single organisms on earth.*

21　*Timberline on Monarch Pass*

22　*Just north of Wolf Creek Pass*

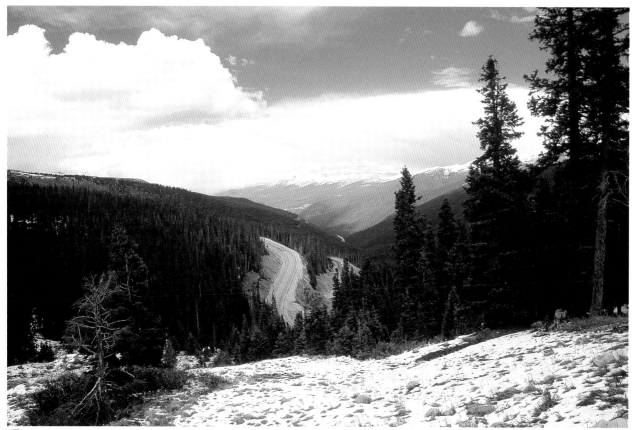

 Berthoud Pass

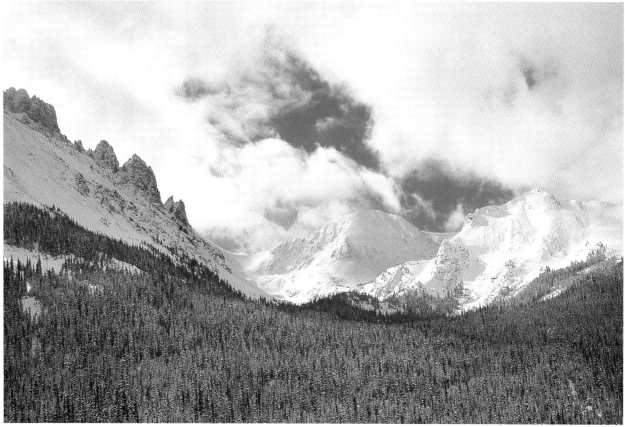

The Continental Divide from Cameron Pass

25 *East of Dinosaur Quarry*

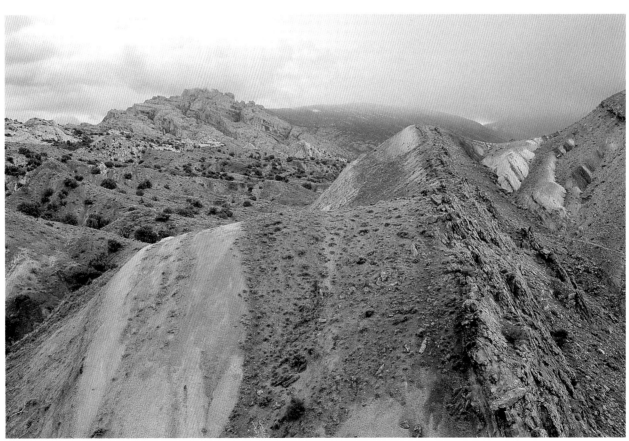

26 *Split Mountain near Dinosaur Quarry*

DINOSAUR
National Monument

LOCATION: Between Dinosaur, Colorado, and Vernal, Utah

ELEVATION: Ranges from 4,758 feet at the Green River campground to 9,006 feet at Zenobia Peak

AREA MAP:

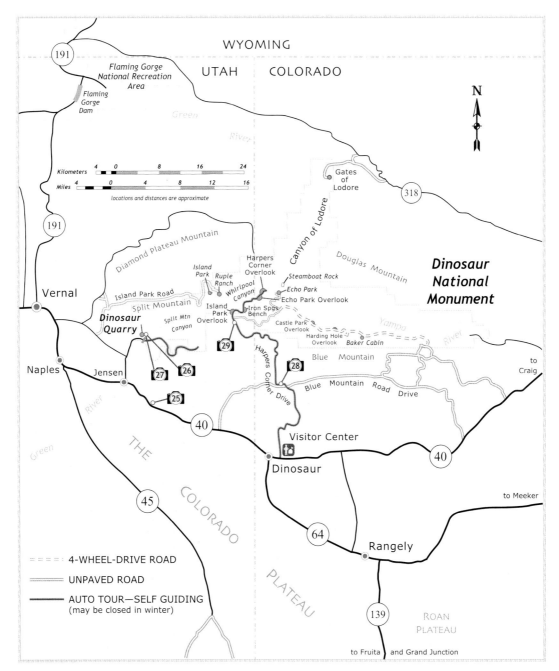

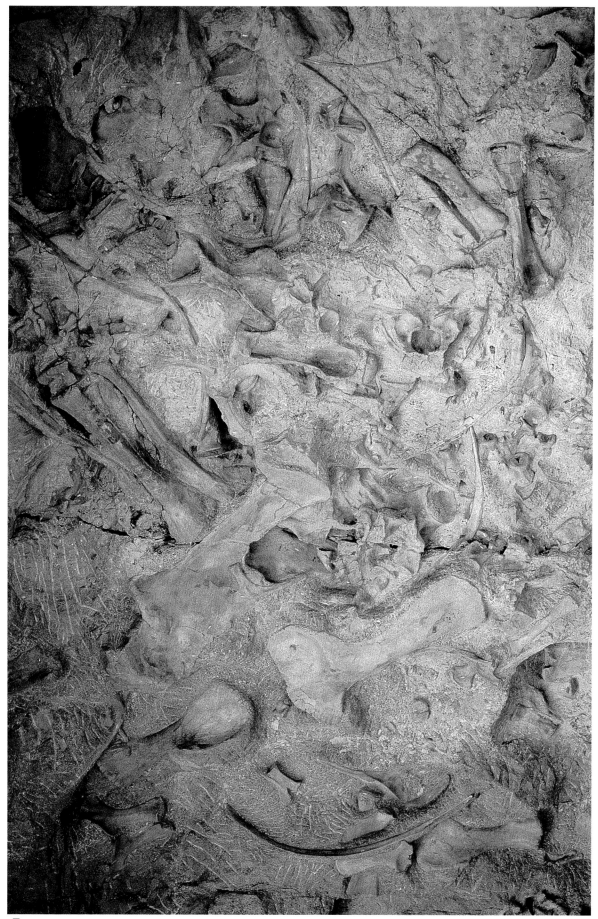

27 *Fossilized dinosaur bones at Dinosaur Quarry*

GEOGRAPHY: Spanning the Utah–Colorado border near Wyoming lies Dinosaur National Monument, a park with a fascinating variety and history. Here, at the Dinosaur Quarry in Utah, one of the world's largest concentrations of dinosaur bones was found in a single cliff of sandstone. More than 2,000 fossils have been left in place in high relief, creating one entire interior wall of the Dinosaur Quarry building. Farther to the east, Harpers Corner Drive crosses the high, rolling Yampa Plateau above canyon country, absent of dinosaur bones but filled with hiking and off-road trails. From the mesas scattered with sagebrush and juniper, a twisted maze of sheer sandstone cliffs drops thousands of feet to deeply layered gorges cut by the Green and Yampa Rivers winding to their confluence at Steamboat Rock.

SUGGESTED LENGTH OF STAY: 1 to 2 days

BEST TIME TO BE THERE: Early-summer afternoons

COLORFUL COMMENTS:

• The Dinosaur Quarry:

"AT LAST IN THE TOP OF THE LEDGE . . . I SAW EIGHT OF THE TAIL BONES OF A BRONTOSAURUS IN EXACT POSITION. IT WAS A BEAUTIFUL SIGHT."

—FROM THE DIARY OF EARL DOUGLASS, paleontologist from the Carnegie Museum in Pittsburgh, August 17, 1909

• Steamboat Rock in Echo Park:

"STANDING OPPOSITE THE ROCK, OUR WORDS ARE REPEATED WITH STARTLING CLEARNESS, BUT IN A SOFT, MELLOW TONE, THAT TRANSFORMS THEM INTO MAGICAL MUSIC. SCARCELY CAN ONE BELIEVE IT IS THE ECHO OF HIS OWN VOICE."

—ABOUT STEAMBOAT ROCK IN ECHO PARK, FROM *REPORT ON THE EXPLORATION OF THE COLORADO RIVER OF THE WEST AND ITS TRIBUTARIES* (1875) BY MAJOR JOHN WESLEY POWELL, one-armed Civil War (Union) veteran of Shiloh who, in 1869, with nine men and four rowboats, was the first to conquer the "mad waters" of the Green and Colorado Rivers

• Whirlpool Canyon:

"THE GREEN IS GREATLY INCREASED BY THE YAMPA, AND WE NOW HAVE A MUCH LARGER RIVER. ALL THIS VOLUME OF WATER, CONFINED, AS IT IS, IN A NARROW CHANNEL AND RUSHING WITH GREAT VELOCITY, IS SET EDDYING AND SPINNING IN WHIRLPOOLS BY PROJECTING ROCKS AND SHORT CURVES, AND THE WATERS WALTZ THEIR WAY THROUGH THE CANYON, MAKING THEIR OWN RIPPLING, RUSHING, ROARING MUSIC."

—MAJOR JOHN WESLEY POWELL, who named the canyon, and also named rapids such as Hells Half Mile and Disaster Falls, where one of his boats was destroyed

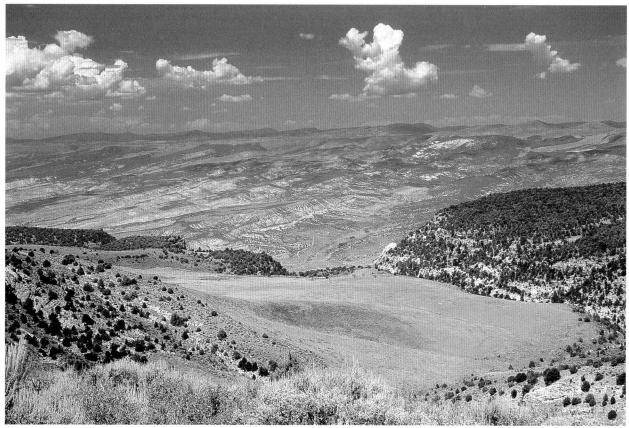

28 *Yampa Plateau*

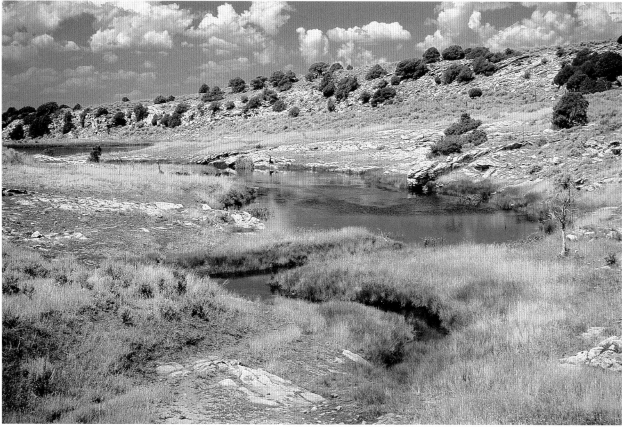

29 *Along Harpers Corner Drive*

COLORFUL NOTE

The fossils most commonly found in Dinosaur National Monument are of the stegosaurus, brontosaurus (also known as the apatosaurus), and allosaurus.

GENERAL INFORMATION

FEE:	Yes	CONVENIENCE STORE:	No
VISITOR CENTER:	Yes	HIKING:	Yes
4WD NEEDED:	Yes	CAMPING:	Yes
GAS WITHIN 5 MILES:	Yes	LODGING WITHIN 5 MILES:	Yes
RESTROOMS:	Yes	PHOTO RATING (1–5):	2.5
FOOD/WATER:	No	CHILD RATING (1–5):	5

FOR MORE INFORMATION

Superintendent
Dinosaur National Monument
4545 East Highway 40
Dinosaur, CO 81610-9724
(970) 374–3000
www.nps.gov/dino

30 *A Walk Through Time Nature Trail*

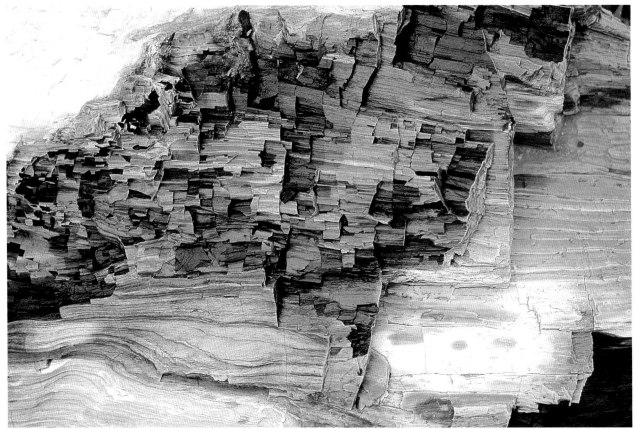

31 *Petrified log*

FLORISSANT

Fossil Beds National Monument

LOCATION: Florissant, Colorado

ELEVATION: 8,400 feet

FRENCH NAME: *Florissant*—"flowering"

LOCAL MAP: The entrance to Florissant Fossil Beds National Monument is located 2 miles south of Florissant on CO 1.

GEOGRAPHY: During the earth's Late Eocene epoch, at a time about thirty-four to thirty-five million years ago, Lake Florissant extended for 12 miles through an ancient forested valley, covering the region now called Florissant Fossil Beds National Monument. The valley, the lake, and its shores were filled with fish and birds, ferns and flowering shrubs, and hardwood trees such as hickory, oak, beech, and maple. Mammals of all kinds roamed the meadows among the cedar, pine, and enormous redwood. Insects of great variety and number thrived in the warm, humid climate.

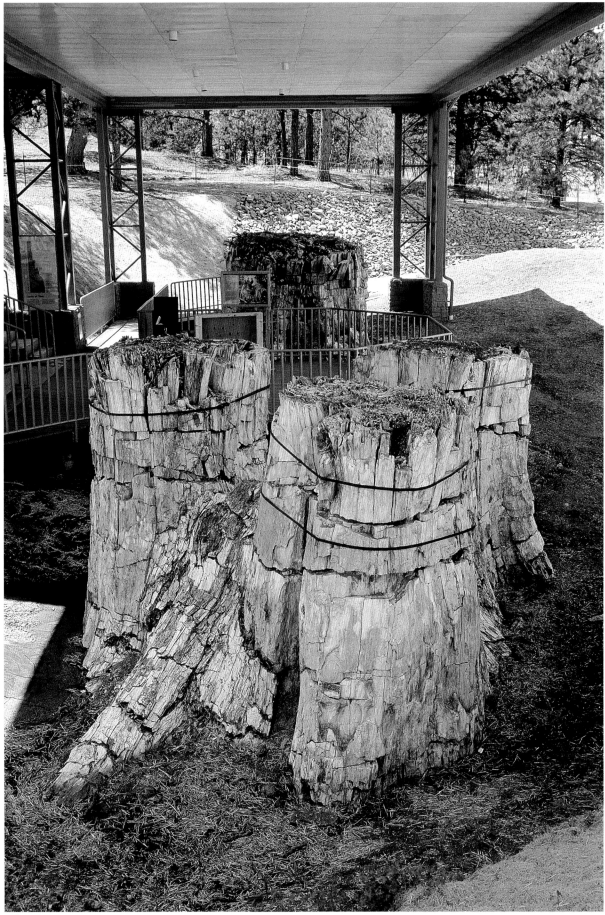

32 *Petrified sequoia stump*

But about 18 miles to the southwest, a volcanic complex began to rumble, then deposited layer after layer of ash and pumice into the valley as it repeatedly erupted and subsided. With each cycle came torrential rain that washed the deposits into the lake, burying the remains of plants, insects, and fish that had settled to the sandy bottom. There they were trapped while water rich in minerals filtered slowly through the deposited sediment, gradually settling and cementing the mud and clay, transforming it to wafer-thin layers of shale. It seeped into the cellular structure of the giant trees, allowing silica deposits to replace the wood and crystallize entire stumps to rock-hard mineral quartz. Volcanic mudflows covered the shale beds with hard conglomerate caprock (breccia), which now underlies the topsoil and protects the fragile fossils from erosion.

Then a tremendous geologic upheaval occurred, which thrust the valley upward by more than a mile and totally transformed the climate and geography of the area. Lake Florissant dried up into an open stretch of treeless meadow. The mix of hardwoods, palms, and ferns died off as the temperature and humidity dropped. Countless species of animals and subtropical insects slipped into extinction. But the fossils left behind in the beds of tuff and gray shale reveal their stories in amazing detail, diversity, and quantity, particularly those of the insect and plant life. From tiny impressions of fragile butterfly wings to the petrified stumps of massive sequoia, Florissant Fossil Beds National Monument has preserved the extraordinary record of an ancient ecosystem unimaginable today.

SUGGESTED LENGTH OF STAY: 3 to 5 hours

BEST TIME TO BE THERE: Late spring when the wildflowers are in bloom

HIGHLIGHTS:

- **A Walk Through Time Trail** is an easy 0.5-mile loop through fossil-bearing shale and petrified sequoia stumps, the remnants of trees that once towered three times higher than a mature ponderosa pine.

- **Petrified Forest Loop** winds for 1.4 miles through pine forests, meadows, and fossil beds to the Scudder Pit and the colorful Big Stump, the largest petrified redwood stump in the park with a circumference of 38 feet.

- The 1878 **Adeline Hornbek Homestead,** with the original cabin and root cellar, was the first homestead claim in the Florissant Valley.

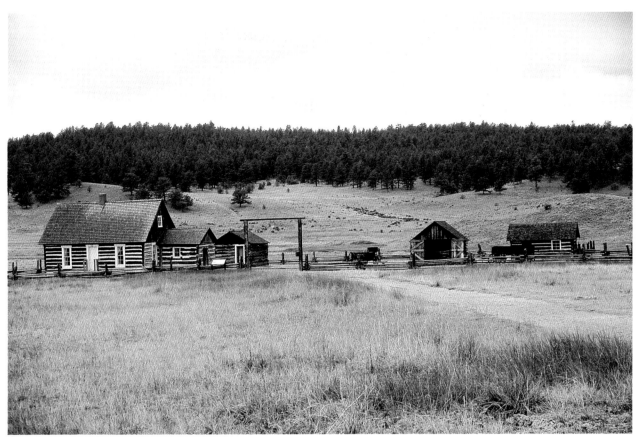

33 *The 1878 Adeline Hornbek Homestead*

34 *Petrified sequoia*

COLORFUL NOTE

Paleontologists have collected more than 50,000 specimens from Florissant Fossil Beds for universities and museums around the world.

COLORFUL COMMENT

"WHEN THE MOUNTAINS ARE OVER THROWN AND THE SEAS UPLIFTED, THE UNIVERSE AT FLORISSANT FLINGS ITSELF AGAINST A GNAT AND PRESERVES IT."

—DR. AUTHOR C. PEALE, Hayden Expedition geologist, 1873

GENERAL INFORMATION

FEE:	Yes	CONVENIENCE STORE:	No
VISITOR CENTER:	Yes	HIKING:	Yes
4WD NEEDED:	No	CAMPING:	No
GAS WITHIN 5 MILES:	Yes	LODGING WITHIN 5 MILES:	No
RESTROOMS:	Yes	PHOTO RATING (1–5):	2
FOOD/WATER:	No	CHILD RATING (1–5):	4

FOR MORE INFORMATION

Superintendent, Florissant Fossil Beds National Monument
P.O. Box 185
15807 Teller County 1, Florissant, CO 80816-0185
(719) 748–3253
www.nps.gov/flfo

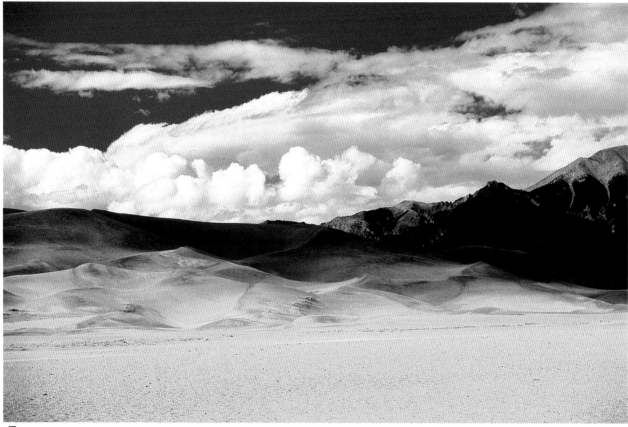

35 *The dunes beneath the Sangre de Cristo Range*

36 *Prairie sunflowers*

GREAT SAND DUNES
National Park

LOCATION: Near Alamosa, Colorado

ELEVATION: 7,600 feet

AREA MAP: Great Sand Dunes National Park is located 38 miles northeast of Alamosa.

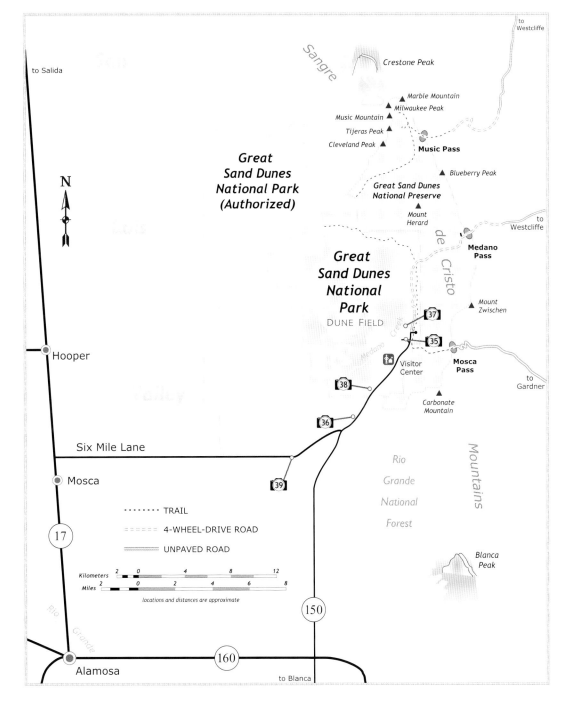

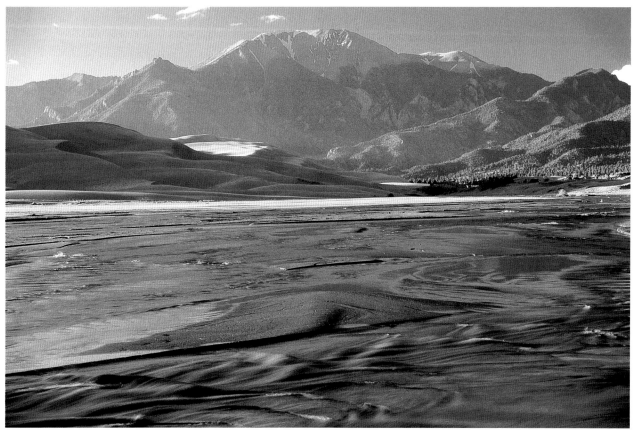

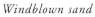 *Mount Herard and Medano Creek*

Windblown sand

GEOGRAPHY: At 750 feet, the mighty Star Dune is the tallest of the numerous sand dunes that have been created in this most unlikely place in a most unusual manner. Winds that carry sand from the Rio Grande River northeast across the San Luis Valley hit a mountain barrier here, and must suddenly drop their heavy load at the base of the Sangre de Cristo Range as the current races up and over the 14,000-foot peaks. These powerful crosswinds continually sculpt and reshape the surfaces of the giant dunes, but a high core moisture content from snowmelt, groundwater, and Medano Creek allows their basic contour to remain stable, resistant to change even over a hundred years.

SUGGESTED LENGTH OF STAY: 1 day

BEST TIME TO BE THERE: Sunset in the fall, when the cottonwoods along Medano Creek turn bright orange and reflect in the shallow, broad flow

HIGHLIGHTS:

- A late-afternoon drive to the sand dunes from Alamosa, very windy and dusty through crystalline and brilliant light.

- Climbing on the dunes while cloud shadows sweep across their surfaces in an endless play of form and color. Graceful arching crests and curves of cream, rose, buff, and gray rise above the ripple tracks that cut exotic braided patterns in the sleek wet sand bed of Medano Creek.

- **Blanca Peak** (14,345 feet), Colorado's fourth highest mountain, seems to rise from the plains without logic or warning to define the southern tip of the Sangre de Cristo Range. This mammoth landmark towers full and round, providing a close and unobstructed view of a fourteener sitting right there by the side of the road, guarding the southern entrance to the park.

COLORFUL NOTE

It is estimated that if all the sand in the dunes could be packed together into a cube, each edge would have a length of almost 2 miles.

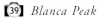 *Great Sand Dunes National Park*

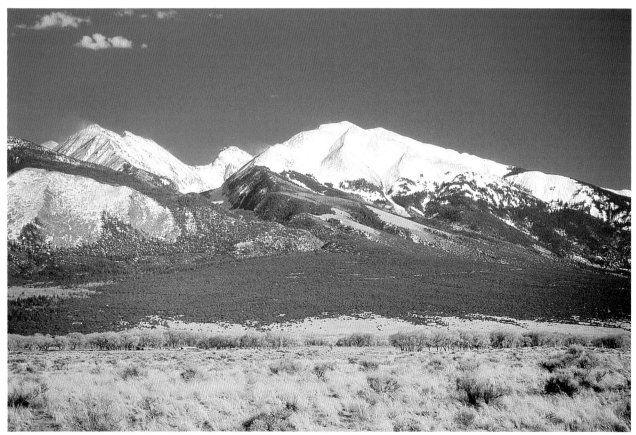

39 *Blanca Peak*

GENERAL INFORMATION

FEE:	Yes	**CONVENIENCE STORE:**	Yes
VISITOR CENTER:	Yes	**HIKING:**	Yes
4WD NEEDED:	No	**CAMPING:**	Yes
GAS WITHIN 5 MILES:	Yes	**LODGING WITHIN 5 MILES:**	Yes
RESTROOMS:	Yes	**PHOTO RATING (1–5):**	3
FOOD/WATER:	Yes	**CHILD RATING (1–5):**	4.5

CAUTION: It takes the average person more than two hours to climb to the top of the dunes. Beware of summer heat and wear shoes, for the surface temperature of the sand can reach a blistering 140 degrees Fahrenheit. Lightning is common and very dangerous on the exposed dunes, where there is no place to take shelter. Medano Creek may be swift and deep during the spring runoff. Relentless wind and blowing sand can destroy camera gear.

FOR MORE INFORMATION

Superintendent
Great Sand Dunes National Park
11500 Highway 150
Mosca, CO 81146-9798
(719) 378–6300
www.nps.gov/grsa

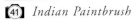 *Maroon Bells in the morning*

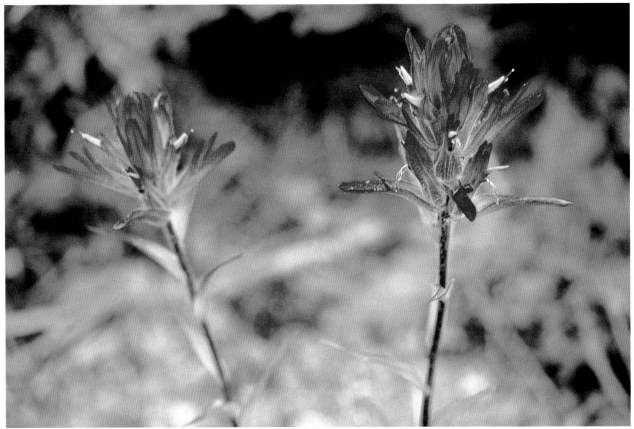

41 *Indian Paintbrush*

THE MAROON BELLS

LOCATION: Just southwest of Aspen, Colorado

ELEVATION: Ranges from 9,580 feet at Maroon Lake to the summit of the Maroon Bells, a pair of mountains: Maroon Peak at 14,156 feet and North Maroon Peak at 14,014 feet

NAME: The Maroon Bells are named for their bell shapes and for their geologic composition, a distinct deep red sandstone of the Maroon formation colored by the weathering of hematite.

LOCAL MAP: From Aspen, drive northwest on CO 82 to the turnabout, and then follow the signs south to Maroon Creek Road, which ascends 9 miles to Maroon Lake.

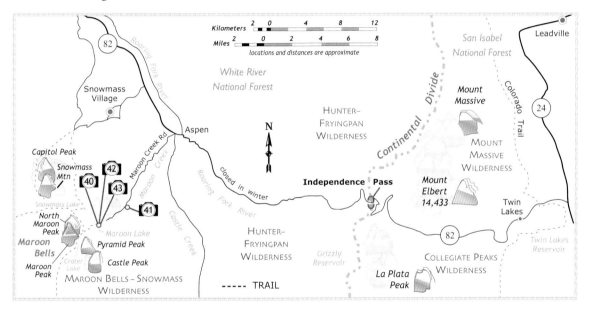

GEOGRAPHY: Serrated symmetrical walls of Maroon formation sandstone that rise diagonally to perfectly matched points describe the pair of mountains called the Maroon Bells. This is one of the most photographed places in the world. In further violation of nature's chaos, these stunning peaks are blessed with a perfectly placed lake at their base into which their reflection falls. Fields of aspens and wildflowers roll down from high ridges into the glacial valley of East Maroon Creek and disappear into forested wilderness.

SUGGESTED LENGTH OF STAY: 1 day

BEST TIME TO BE THERE: Anytime of day, anytime of year

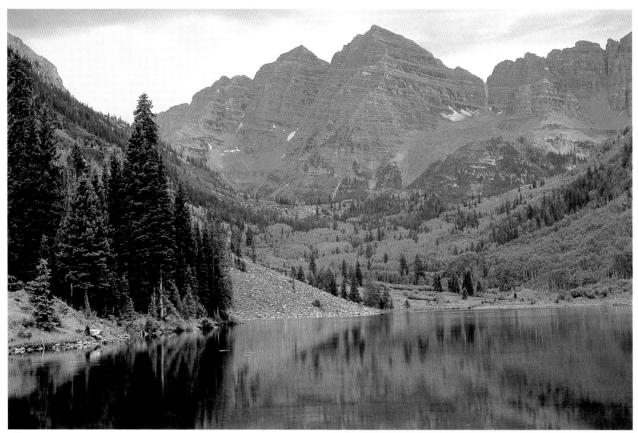

 Maroon Bells in the afternoon

43 *Maroon Lake*

HIGHLIGHTS:

- **Maroon Lake** (9,580 feet) is a classic glacial tarn dammed by boulders and tree fragments from rockfalls and landslides. An easy 1-mile round-trip trail runs along its north shore.

- **East Maroon Creek Trail** winds its way downstream for 3.2 miles one way, passing (at about 2 miles) abundant wildflowers, including Colorado blue columbine, western red paintbrush, and silver lupine.

COLORFUL NOTE

Aspen trees grow as genetically identical clones, linked together by a shared root system. A grove of aspen, no matter how large, is considered by scientists to be a single living organism.

GENERAL INFORMATION

FEE:	Yes	CONVENIENCE STORE:	No
VISITOR CENTER:	No	HIKING:	Yes
4WD NEEDED:	No	CAMPING:	Yes
GAS WITHIN 5 MILES:	Yes	LODGING WITHIN 5 MILES:	Yes
RESTROOMS:	Yes	PHOTO RATING (1–5):	5
FOOD/WATER:	No	CHILD RATING (1–5):	4

CAUTION: Mountain climbers beware—crumbly sandstone underfoot!

FOR MORE INFORMATION

Aspen Ranger District
806 West Hallam
Aspen, CO 81611
(970) 925–3445

White River Interpretive Association
P.O. Box 3136
Aspen, CO 81612
(970) 925–3445

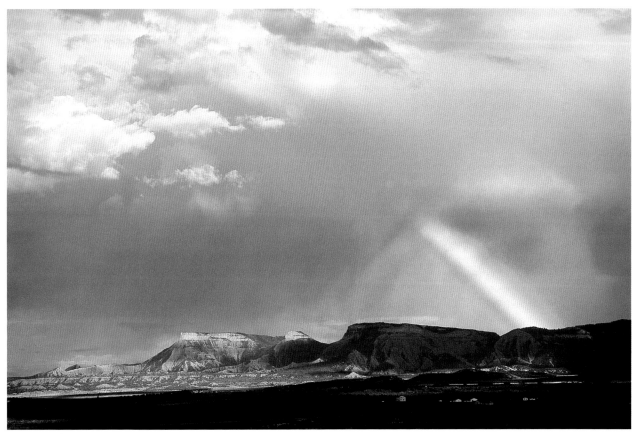

Mesa Verde

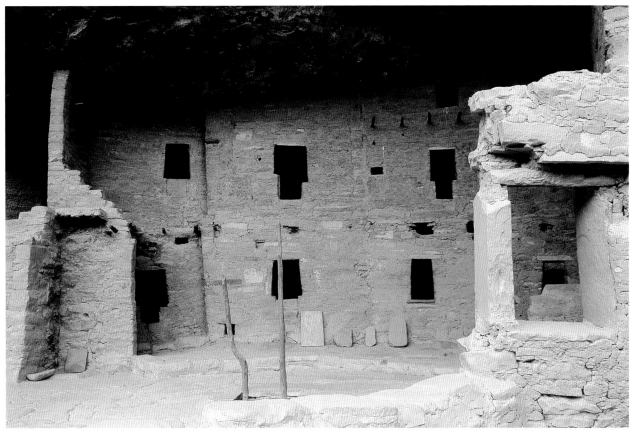

44 *Pueblo at the Spruce Tree House ruins*

MESA VERDE
National Park

LOCATION: Near Cortez, Colorado

ELEVATION: Ranges from 7,000 feet at Chapin Mesa to 8,571 feet at Park Point

SPANISH NAME: *Mesa Verde*—"green table"

GEOGRAPHY: Mesa Verde National Park is one of America's greatest archaeological treasures. The mesa itself is an immense flat-topped mountain, mantled in green with Douglas fir, pinyon and ponderosa pine, Gambel and scrub oak, and occasional stands of aspen. It rises 2,000 feet from the floor of the Mancos Valley, which stretches east to the La Plata Mountain Range, topped by Hesperus Peak (13,232 feet) and its satellites. Throughout its slopes and canyons are hidden as many as 4,000 ruin sites and 600 cliff dwellings of the Ancestral Pueblo People (A.D. 500–1300). Twenty major ruin sites have been preserved and are open to the public. Of these, five are cliff dwellings, which require the guidance of a park ranger.

SUGGESTED LENGTH OF STAY: 1 to 2 days

BEST TIME TO BE THERE: Early to midafternoon, in soft light

HIGHLIGHTS:

- **Park Point** (8,571 feet) faces west, and from here the view sweeps unbroken for hundreds of miles over the vast and remote Colorado Plateau. On the northeast horizon rest the shadowy cones of the San Miguel Mountains. Just to the southwest, beyond Sleeping Ute Mountain and Ute Peak, are the Canyonlands of Utah, which sprawl beneath the La Sal and Abajo Ranges. As the earth curves farther to the south, the distant Carrizo and Chuska Mountains are barely visible, spanning the Arizona–New Mexico border. And finally, from the San Juan Basin of New Mexico, rises the lonely Shiprock, a solitary volcanic peak floating on the surface of the dry and barren plateau.

- The burn damage from the 2000 Bircher and Pony Fires is heartbreaking. Entire hillsides have been wiped out for miles and miles. But the view of Sleeping Ute Mountain and the snowcapped ranges on the horizon remind us that some things never change.

COLORFUL NOTE

In 1978 Mesa Verde National Park was designated a United Nations Educational, Scientific, and Cultural Organization (UNESCO) World Heritage Site.

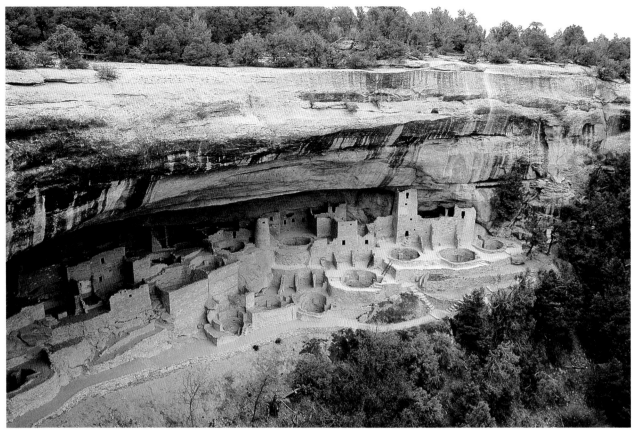

45 *Cliff Palace*

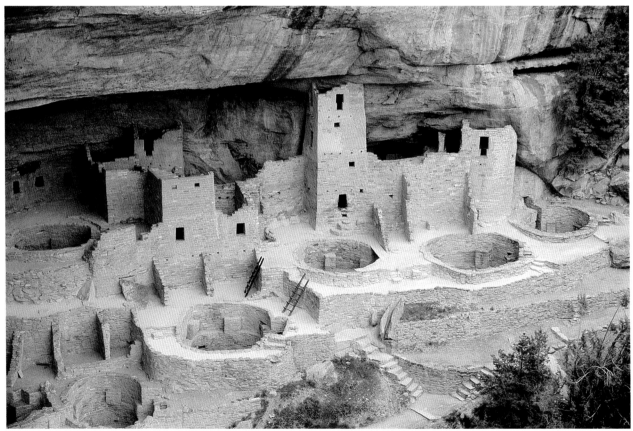

46 *Tower and kivas*

LOCAL MAP: The entrance to Mesa Verde National Park is located 9 miles east of Cortez or 35 miles west of Durango on US 160.

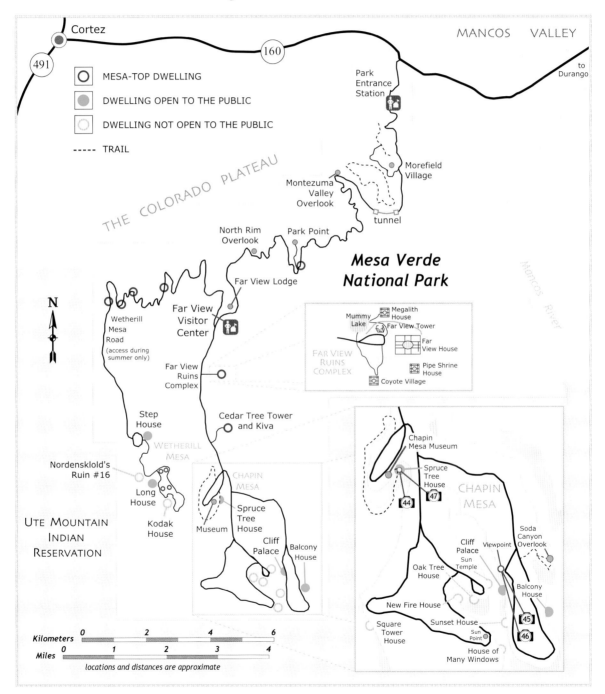

Evening storm gathering over Mesa Verde

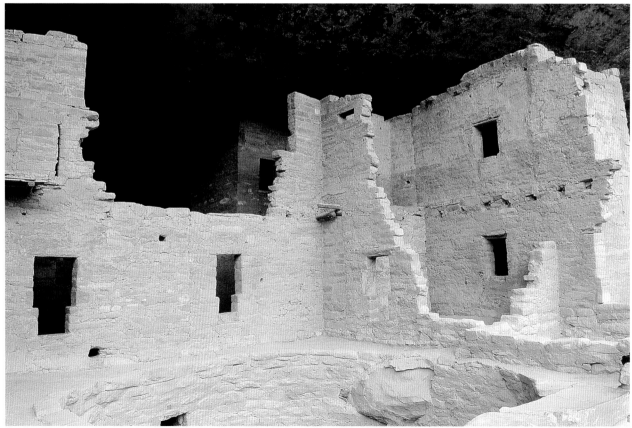

47 *Spruce Tree House ruins*

Many fine artifacts from the Ancestral Puebloan culture, such as pottery, clothing, tools, and baskets, are on display in the Chapin Mesa Museum. What remains of their architecture is a remarkable variety of structures and spaces built over three distinct periods:

- **A.D. 550–750:** Early Puebloans from the "Modified Basketmaker Period" built subterranean, mud-plaster-and-pole pit houses throughout the canyons and atop Wetherill and Chapin Mesas.

- **A.D. 750–1100:** Techniques were developed for building larger stone structures, such as round and square towers, kivas (ceremonial rooms or gathering places), and masonry houses around open courts (pueblos). Cultivation of crops was expanded and refined.

- **A.D. 1100–1300:** Later Ancestral Puebloans advanced their architectural skills into complex constructions of multiple stories around a common plaza, and eventually moved into cliff dwellings tucked in natural alcoves and beneath overhangs in the canyon walls. By far the largest and most renowned of the cliff dwellings is the Cliff Palace, a stone labyrinth of more than 150 rooms and twenty-three kivas. Built beneath a huge overhang in the east wall of Cliff Canyon, it is best seen from Cliff Palace Viewpoint or Sun Point Overlook on the opposing west rim. It remains a mystery why the Ancestral Pueblo People abandoned Mesa Verde less than one hundred years after completing the great Cliff Palace, but it is believed that in A.D. 1276, a twenty-three year period of drought began and forced their migration south to the pueblos of the Rio Grande and Little Colorado Basins.

GENERAL INFORMATION

FEE:	Yes	**CONVENIENCE STORE:**	Yes
VISITOR CENTER:	Yes	**HIKING:**	Yes
4WD NEEDED:	No	**CAMPING:**	Yes
GAS WITHIN 5 MILES:	Yes	**LODGING WITHIN 5 MILES:**	Yes
RESTROOMS:	Yes	**PHOTO RATING (1–5):**	3
FOOD/WATER:	Yes	**CHILD RATING (1–5):**	5

NOTE: Many park services, including Far View Motor Lodge, are closed from mid-October through mid-May.

FOR MORE INFORMATION

Superintendent, Mesa Verde National Park
P.O. Box 8, Mesa Verde, CO 81330-0008
(970) 529–4465
www.nps.gov/meve

48 *Echo Lake*

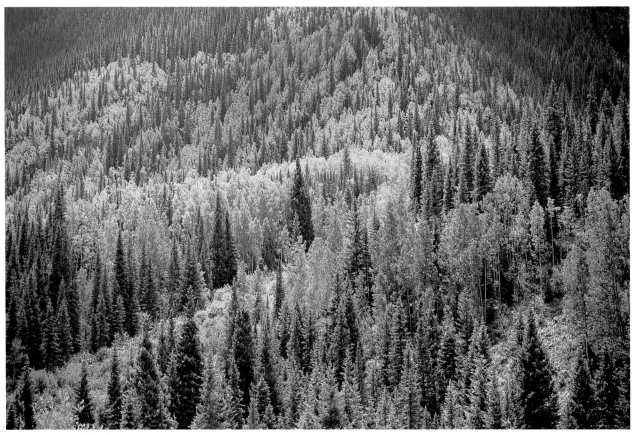

Mount Evans Wilderness

MOUNT EVANS

LOCATION: In the Front Range, 40 miles west of Denver, Colorado

ELEVATION: 14,264 feet

NAME: Mount Evans was named for Dr. John Evans, second territorial governor of Colorado, a physician, educator, and builder of railroads.

AREA MAP: From Denver, drive 40 miles west on I–70 to Exit 240 in Idaho Springs. Turn south onto CO 103 and drive 14 miles to the fee station just beyond Echo Lake, and then another 14.5 miles on CO 5 to the summit.

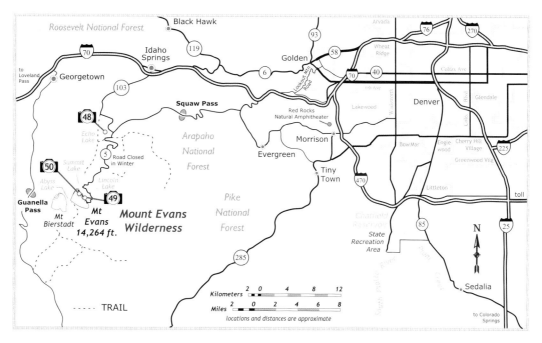

GEOGRAPHY: Along with Pikes Peak and Longs Peak, Mount Evans is one of a triplet of massive summits that dominate the Front Range. It is Denver's mountain, prominent from the city as it looms silent and unchanging in wilderness just beyond the urban sprawl.

SUGGESTED LENGTH OF STAY: 1 day

BEST TIME TO BE THERE: Early morning in spring when the wildflowers are blooming. Mount Evans Scenic Byway is open Memorial Day through Labor Day only.

HIGHLIGHTS:

- **Mount Evans Scenic Byway** is the highest paved road in the North America, rising 7,000 feet from Idaho Springs to the top of Mount Evans, which overlooks central Colorado, the Continental Divide, and the snowy peaks of the Front Range lifting from the eastern plains.

- **Echo Lake** (10,600 feet) in subalpine forest, and historic Echo Lake Lodge.

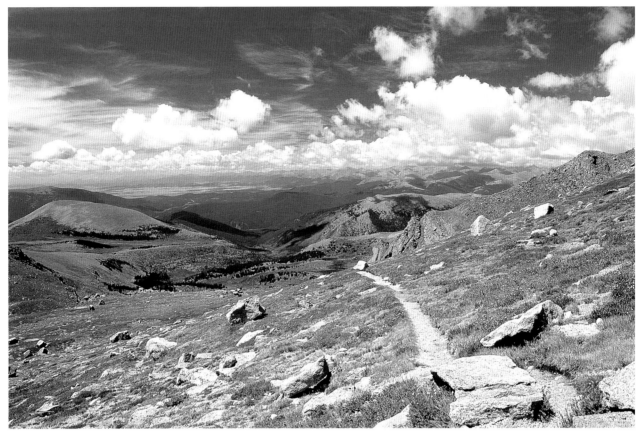

49 *Just below the summit, looking west-southwest across Kataka Mountain (12,441 feet) in the left foreground, with South Park, the Sawatch Range, and the Mosquito Range on the horizon*

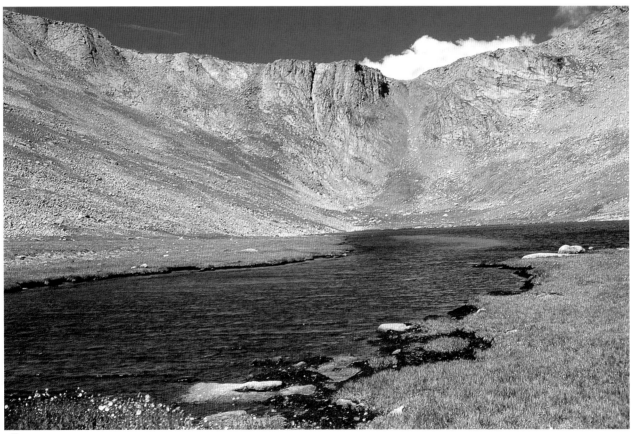

50 *Summit Lake*

- **Summit Lake** (12,800 feet), rimmed by the steep slopes of Mount Evans, was once a high mountain cirque scooped out by erosive glaciers during the Ice Age. It soon filled with water and became a small lake known as a glacial tarn. Above Summit Lake the scenic byway becomes a narrow ledge cut into the mountainside and ascends to the summit parking lot (14,130 feet) in a series of steep switchbacks and tight hairpin turns.

- **Mount Evans summit** (14,264 feet) can be reached by a 0.25-mile trail that climbs the last 134 feet from the parking lot to the rocky top of the mountain where, on a clear day, visibility is almost 200 miles. The boundless prairie of Kansas stretches eastward beyond the Front Range to a line that meets the sky. To the north spread the high peaks of Rocky Mountain National Park. Torreys Peak (14,267 feet), Grays Peak (14,270 feet), Mount Bierstadt (14,060 feet), the Continental Divide, Mount Elbert (14,433 feet), and the rounded tops of the Sawatch Range etch the western horizon from right to left. South Park, a vast intermontane basin, lies between the ranges to the southwest, and to the south Pikes Peak lifts its shoulders against the distant Wet Mountains and the jagged Sangre de Cristo Range.

- **Mount Evans Wilderness,** as defined by Congress, is "an area where the Earth and its communities of life are untrammeled by man, where man himself is just a visitor." Four trailheads lead from the scenic byway to more than 100 miles of hiking trails in a 74,401-acre wilderness of tundra and wildflowers, marmots, bighorn sheep, and the more elusive white mountain goat, usually found on meadows at upper elevations.

GENERAL INFORMATION

FEE:	Yes	CONVENIENCE STORE:	No
VISITOR CENTER:	Yes	HIKING:	Yes
4WD NEEDED:	No	CAMPING:	Yes
GAS WITHIN 5 MILES:	No	LODGING WITHIN 5 MILES:	No
RESTROOMS:	Yes	PHOTO RATING (1–5):	4
FOOD/WATER:	Yes	CHILD RATING (1–5):	3

CAUTION: See "General Precautions" on pages 17–19, especially "Driving at High Altitude," and "High Altitude and Health."

FOR MORE INFORMATION

Clear Creek District Ranger
101 Chicago Creek, P.O. Box 3307
Idaho Springs, CO 80452
(303) 567–2901
www.fs.fed.us/r2

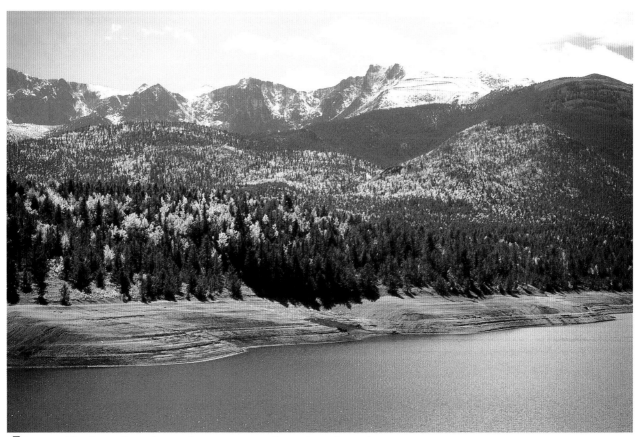

51 *Switchbacks to the Pikes Peak summit rise above Crystal Creek Reservoir.*

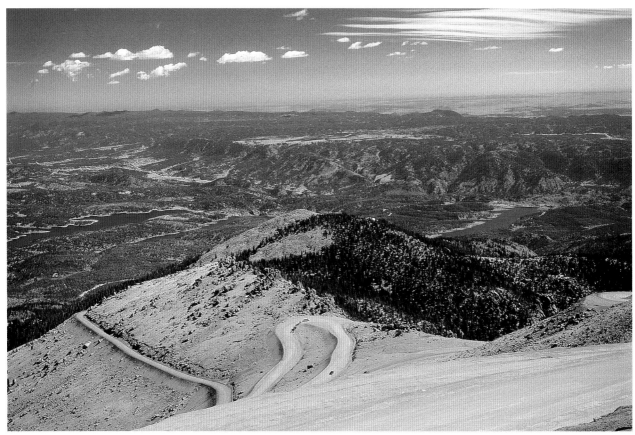

52 *View from the summit*

PIKES PEAK

LOCATION: In Cascade, just west of Colorado Springs, Colorado

ELEVATION: Ranges from 7,400 feet in Cascade to 14,110 feet at the summit

NAME: During an 1806 survey of the Louisiana Purchase, Lieutenant Zebulon Pike led an expedition of soldiers into the Rockies. On November 15 he wrote, "At two o'clock I thought I could distinguish a mountain to our right, which appeared like a small blue cloud." Later in that journey he described the lofty summit of Pikes Peak, "which was entirely bare of vegetation and covered with snow, now appeared at the distance of fifteen to sixteen miles from us, and as high again as what we had ascended, and would have taken a whole days march to have arrived at its base, when I believe no human being could have ascended to its pinnacle." Although Pike never reached its summit, his "Grand Peak" was named in his honor.

LOCAL MAP: Pikes Peak Highway begins in Cascade off US 24, about 9 miles west of I–25 (Exit 141 to US 24) in Colorado Springs.

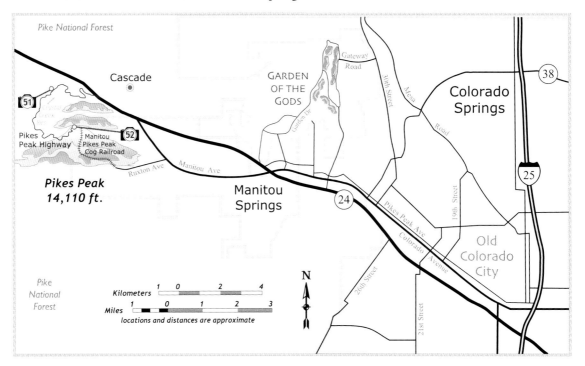

GEOGRAPHY: Guardian of the Front Range, Pikes Peak is America's mountain, and is conquered by more people than any other high summit in the country. It is composed of weathered pink Pikes Peak granite, chiseled by glaciers, in a region renowned for its minerals and gemstones such as quartz, topaz, zircon, and fluorite.

SUGGESTED LENGTH OF STAY: 3 to 4 hours

BEST TIME TO BE THERE: Midday during the summer. Pikes Peak Highway is open only when weather permits, usually May to October.

Spacious skies

Hayman Fire destruction in Pike National Forest

HIGHLIGHTS: The Pikes Peak Highway climbs 6,710 feet in the 19 miles from the tollgate to the summit at 14,110 feet. This road is safe but very scary toward the top—narrow, sharp hairpin turns, no guardrails or shoulders, and unpaved and rough through alpine tundra for the last several miles.

- Near Mile Marker 2: Ute Pass Overlook sits above Ute Pass Fault, a precipitous canyon incised into the Front Range escarpment by Fountain Creek.
- Near MM 3: Crowe Gulch hiking trail.
- Near MM 6: Crystal Creek Reservoir and gift shop.
- Near MM 9: Halfway Picnic Ground, at about 10,000 feet.
- Near MM 13: Historic Glen Cove (11,425 feet), in a north-facing glacial cirque just below timberline, has a gift shop, snacks, and ranger talks.
- MM 14.7: Devil's Playground, above timberline, is an open, windswept expanse of tundra covered with pink granite boulders eroded into all shapes and sizes.
- From MM 14 to 16: The road edges another 1,000 feet up the mountain in a series of eight treacherous switchbacks ending at the 16-Mile Turnout.
- Near MM 17: Bighorn Sheep Overlook.
- Near MM 19: Pikes Peak summit (14,110 feet)—the road pushes through the shattered rock of the western slope to scale the final pyramid.

COLORFUL NOTE

The song "America the Beautiful" began as a poem written in 1893 by Katharine Lee Bates, professor of English literature at Wellesley College. Standing atop the legendary Pikes Peak, she was stunned by what she saw: the immense arching sky and the shadowy, jagged profile of the Rocky Mountains rising suddenly from the vast flatness of the eastern plains. Her poem first appeared in print in 1911 and was immediately set to music.

GENERAL INFORMATION

FEE:	Yes	**CONVENIENCE STORE:**	No
VISITOR CENTER:	Yes	**HIKING:**	Yes
4WD NEEDED:	No	**CAMPING:**	No
GAS WITHIN 5 MILES:	Yes	**LODGING WITHIN 5 MILES:**	Yes
RESTROOMS:	Yes	**PHOTO RATING (1–5):**	4
FOOD/WATER:	Yes	**CHILD RATING (1–5):**	4

CAUTION: See "General Precautions" on pages 17–19, especially "Driving at High Altitude," and "High Altitude and Health."

FOR MORE INFORMATION

(800) 318–9505 or (719) 385–7325
www.pikespeakcolorado.com

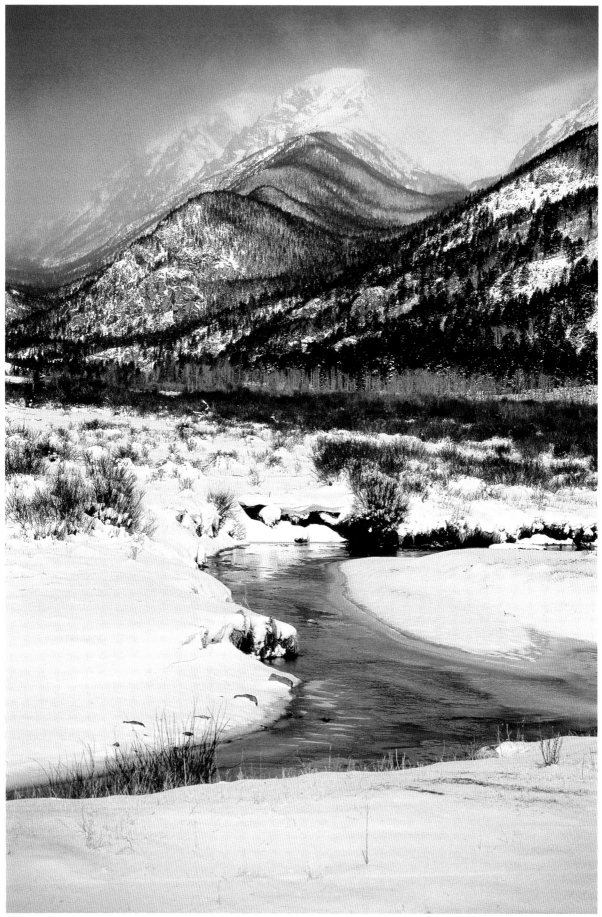

53 *Looking into Endovalley from West Horseshoe Park*

ROCKY MOUNTAIN

LOCATION: Between Estes Park and Granby, Colorado

ELEVATION: Ranges from 7,840 feet at the park headquarters to 14,255 feet at Longs Peak

AREA MAP:

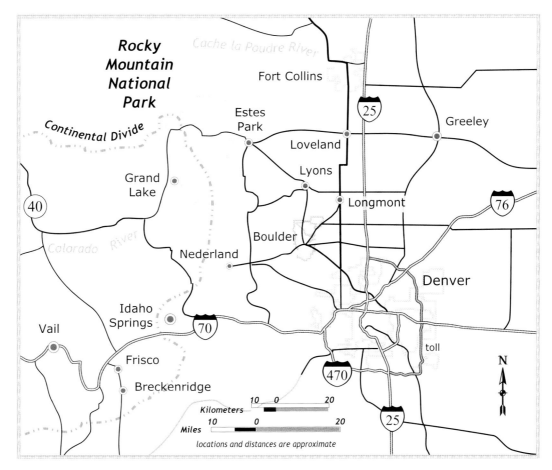

GEOGRAPHY: More than in any other place, the Rocky Mountains at their most glorious are found here, in this little corner of heaven. The park is dominated in the south by Longs Peak, lifting from the plains to touch the sky as silent sentinel of the Front Range. Meadows and lakes surround its base; dense forests rise along its granite slopes. Moraine Park spreads out to the east, a quintessential montane valley divided by the Big Thompson River. To the north is unbound enormity—broad open expanses of barren tundra, great fields of mat grass and shattered rock, long rolling hillsides, and canyons rimmed by the frosty peaks of the Never Summer Mountains.

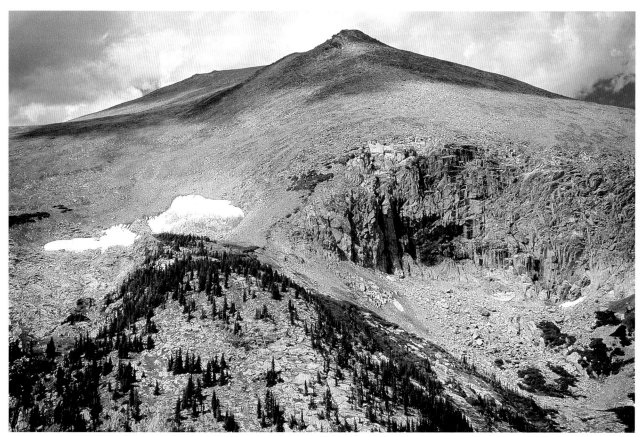

Timberline and alpine tundra

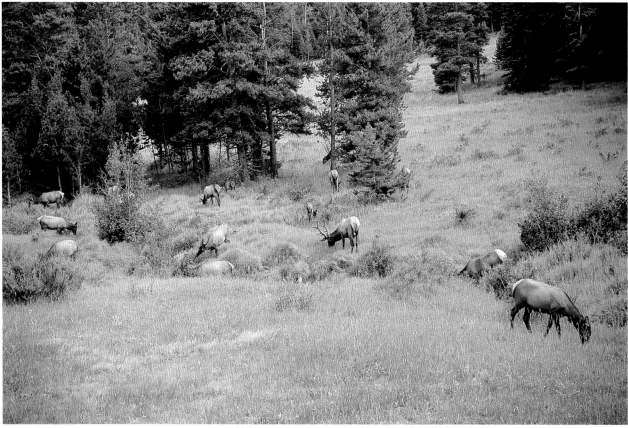

Elk grazing at dusk

LOCAL MAP: The east entrance to Rocky Mountain National Park is just west of Estes Park via either US 34, US 36, or CO 7. The west entrance is just north of Grand Lake on US 34.

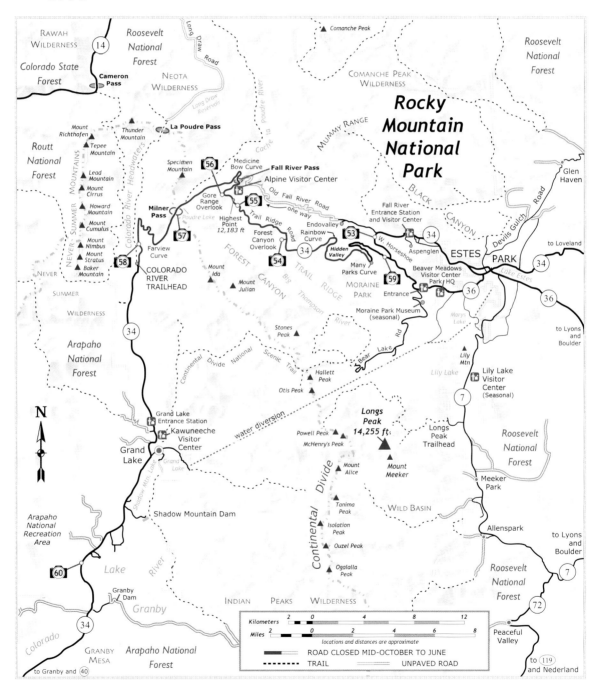

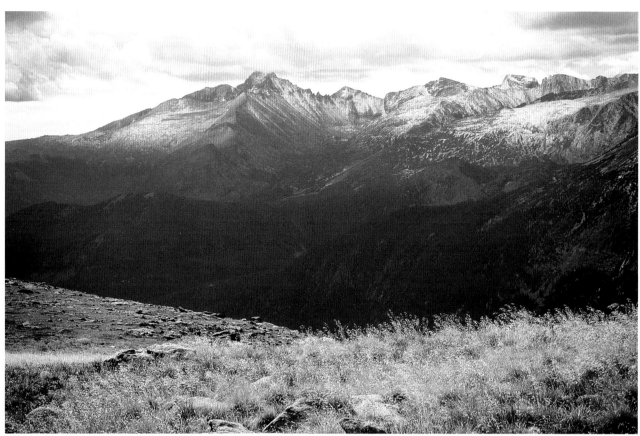

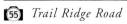 *Longs Peak from Forest Canyon Overlook*

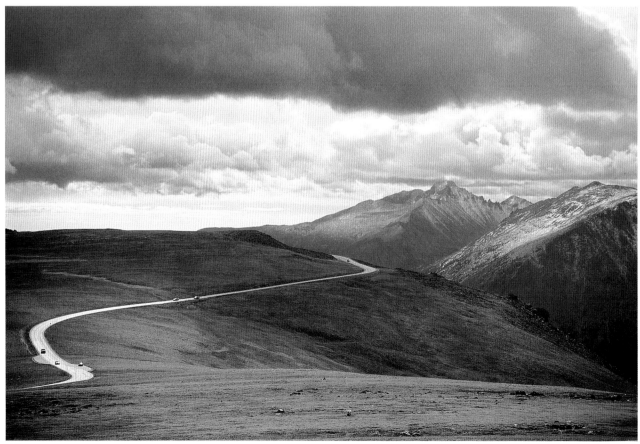

55 *Trail Ridge Road*

Rocky Mountain

Suggested Length of Stay: 4 hours to drive through it, or 3 days to explore it

Best Time to Be There: Late spring, when the alpine meadows and broad valleys are filled with blooming wildflowers

Highlights:

- **Trail Ridge Road** (US 34), the highest continuous paved through-highway in North America, runs for 45 miles through Rocky Mountain National Park. After a rapid ascent from Estes Park to the towering crest of the Front Range, and rising beyond timberline to 12,183 feet, this ribbon of road curls through alpine tundra and among snow-dusted layers of peaks for more than 10 miles before crossing the Continental Divide at Milner Pass and descending on more gentle slopes to Grand Lake.

- **Longs Peak** (14,255 feet), with its sheer granite east face called the Diamond, is the only fourteener and the highest of the seventy-eight named mountains within the park with elevations above 12,000 feet, eighteen of which exceed 13,000 feet.

- **The Gore Range Overlook,** from east to west: Longs Peak (14,255 feet); Stones Peak (12,922 feet); Sprague Mountain (12,713 feet); Hayden Spire; Hayden Gorge; Terra Tomah Mountain (12,718 feet); Chief Cheley Peak (12,804 feet); Mount Julian (12,928 feet); Mount Ida; Forest Canyon; the Gore Range, 75 miles distant; the Never Summer Mountains; the Crater; Specimen Mountain (12,489 feet).

- The Continental Divide and Poudre Lake at Milner Pass (10,758 feet).

- Woodlands of ponderosa and lodgepole pine, forests of Douglas and subalpine fir, juniper, Englemann spruce, willow trees, and groves of aspen.

- Valleys, meadows, canyons, and mountain streams, all filled with wildlife, including elk, mule deer, bighorn sheep, black bears, coyotes, bobcats, mountain lions, numerous birds, and several species of trout.

- One hundred fifty pristine alpine lakes and glacial tarns, secluded in the back-country.

56 *The Gore Range Overlook*

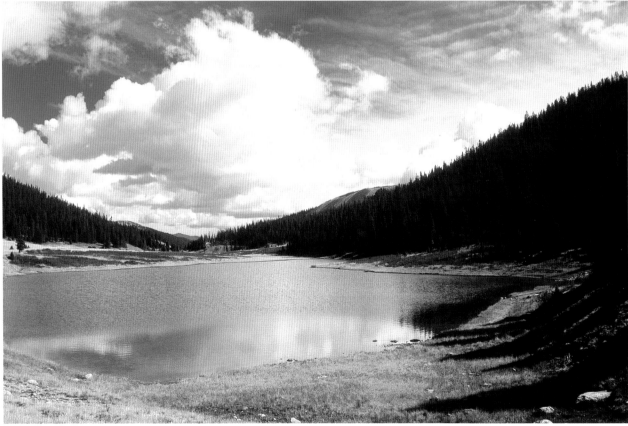

57 *Poudre Lake at Milner Pass*

- Seven hundred species of wildflowers; of these, 185 grow above timberline, including alpine forget-me-not, buttercup, sunflower (*Rydbergia* spp.), Parry primrose, marsh marigold, dwarf clover, bistort, and phlox.

- Three hundred sixty miles of trails for access to hiking, climbing, skiing, fishing, camping, horseback riding, and mountain biking.

COLORFUL COMMENT

"HERE ARE MOORLANDS, PEAKS, PLATEAUS, AND PRECIPICES—A WORLD BY ITSELF IN THE SKY—MORE THAN TWO MILES ABOVE THE SURFACE OF THE SEA."

—ENOS MILLS, 1924

COLORFUL NOTE

The Colorado River begins its long and mighty journey southwestward from Rocky Mountain National Park. Its headwaters are found here at La Poudre Pass above the glacier-carved Kawuneeche Valley, Arapaho for "valley of the coyote," a broad and flat stretch of land filled with willows and beaver ponds.

GENERAL INFORMATION

FEE:	Yes	CONVENIENCE STORE:	No
VISITOR CENTER:	Yes	HIKING:	Yes
4WD NEEDED:	No	CAMPING:	Yes
GAS WITHIN 5 MILES:	Yes	LODGING WITHIN 5 MILES:	Yes
RESTROOMS:	Yes	PHOTO RATING (1–5):	5
FOOD/WATER:	Yes	CHILD RATING (1–5):	3

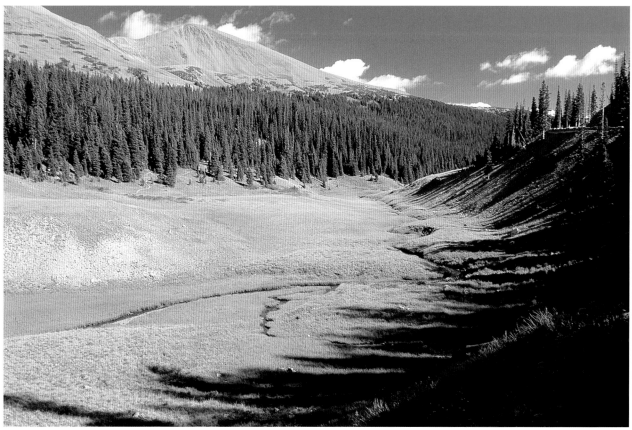

58 *Colorado River headwaters in Kawuneeche Valley beneath the Never Summer Mountains*

59 *Near Deer Ridge Junction*

CAUTION: Rocky Mountain National Park is vast and complex, with fragile ecosystems that need protection but that present many hidden hazards to the unprepared visitor. Read information carefully, and obey and respect all posted or published park regulations. Trail Ridge Road is snowpacked for most of the year, and is open end to end from May to October only, or as weather permits. The crystalline rarefied mountain air can cause altitude sickness and dehydration in the healthiest, and can be dangerous to those with cardiac or respiratory conditions.

FOR MORE INFORMATION

Superintendent
Rocky Mountain National Park
1000 Highway 36
Estes Park, CO 80517-8397
(970) 586–1206
www.nps.gov/romo

Near US 40 in Granby

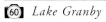 *Lake Granby*

Mount Powell of the Gore Range from CO 9

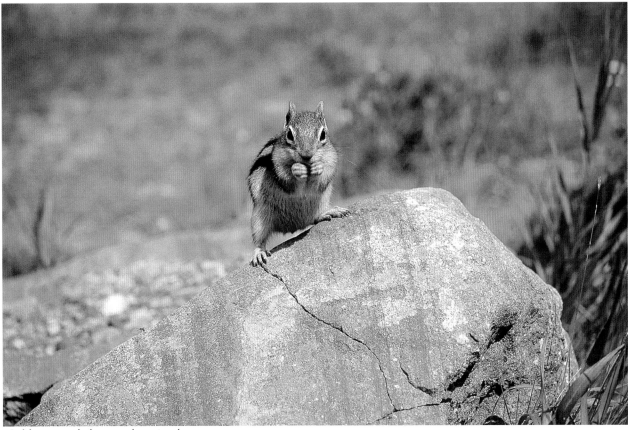

Golden-mantled ground squirrel

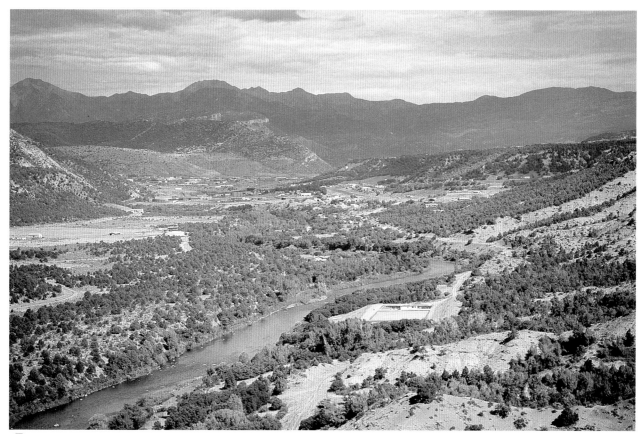

61 *The Animas River Valley, cut by glaciers, just south of Durango*

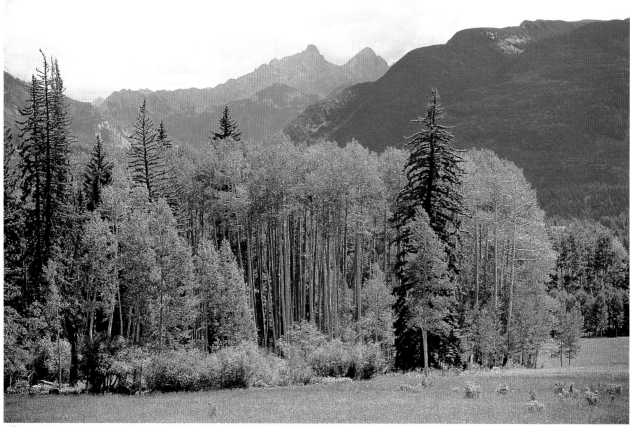

62 *The Needle Mountains*

THE SAN JUAN
Skyway

LOCATION: Southwestern Colorado

ELEVATION: Ranges from about 6,200 feet in Cortez to about 11,018 feet on Red Mountain Pass

AREA MAP:

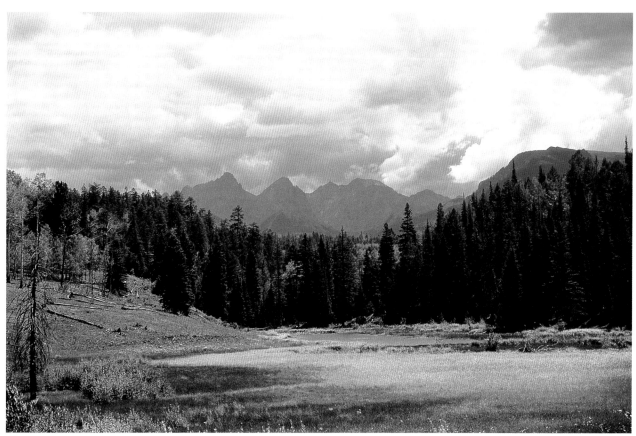

63 *Sunlight, Eolus, and Window Peaks of the Needle Mountains*

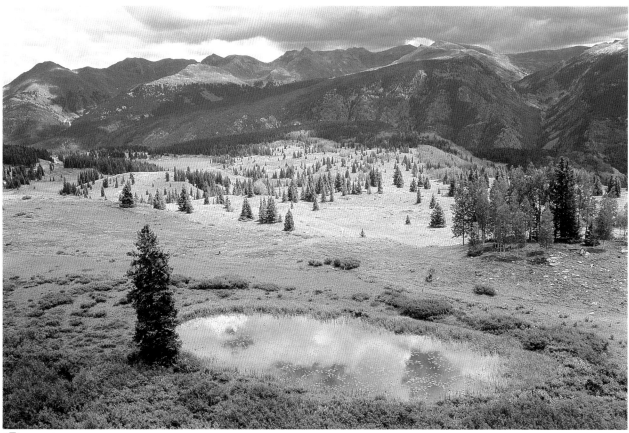

64 *Looking southwest from the Molas Pass summit*

GEOGRAPHY: The San Juan Skyway offers, quite probably, the most spectacular 236 miles of paved mountain driving in North America. An astonishing feat of engineering, this narrow road winds and curls among the towering sheer walls and jagged snow-capped crests of the San Juan Mountains, a nonlinear range formed from volcanic flow only thirty-five million years ago, higher and younger than all others in the Rockies and so less softened by time. Every element of alpine beauty is here, in a span of elevation and terrain that includes:

- High mountain passes and rugged plateaus.

- Steep descending canyons and gorges.

- Lush river valleys.

- Waterfalls, lakes, and streams.

- Forests of ponderosa pine, Colorado blue spruce, Engelmann spruce, juniper, and aspen groves.

- Broad meadows of tall grasses and wildflowers.

- Colorful, highly mineralized rock rich in galena (lead/silver ore) and the collapsing wooden and metal structures that remain from the gold- and silver-mining boom of the late 1800s.

SUGGESTED LENGTH OF STAY: 1 day to drive it or 5 days to explore it

BEST TIME TO BE THERE: The third week in September

HIGHLIGHTS:

- **Durango** (6,512 feet), the Animas River Valley, and the La Plata Mountains (Spanish for "silver mountains"). Originally a mining and smelting center, Durango is a natural gateway to the Southwest and the Four Corners region. The Durango & Silverton Narrow Gauge Railroad is powered by a coal-burning steam locomotive and has been running continuously since 1882. Make reservations well in advance, and allow at least nine hours for the round trip through the Animas River Canyon to Silverton.

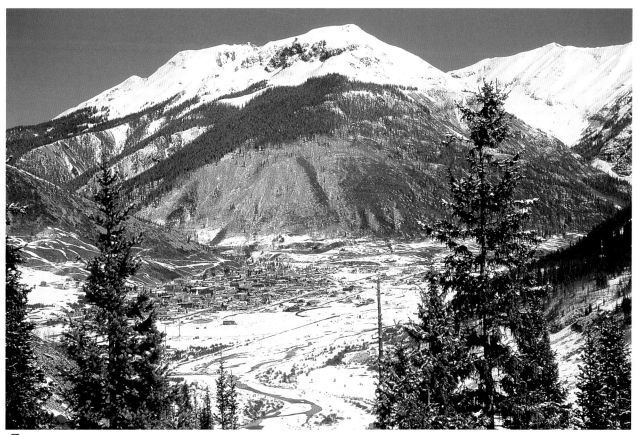

65 *Silverton*

66 *The Durango & Silverton Narrow Gauge Railroad pulling into Silverton*

- **Molas Divide** (10,910 feet) and Molas Summit (10,970 feet), with Engineer Mountain (12,968 feet) to the southwest, Twin Sisters (13,432 feet) to the northwest, Sultan Mountain (13,368 feet) and Molas Lake to the north, Whitehead Peak (13,259 feet) to the east, and, to the southeast, the sharp tips of the Neeedles and the Grenadier Ranges.

- **Silverton** (9,318 feet), as in "Silver-By-The-Ton," remains a historic and active mining town. Within the more than 600 square miles of San Juan County, the mountains are so dense that the flattest and widest stretch of land is here in Baker's Park, a glacial valley encircled by peaks that is only 1 mile wide and less than 2 miles long.

- **Red Mountain Pass** (11,018 feet) and the three Red Mountain Peaks (12,592 feet, 12,219 feet, and 12,890 feet) were the site of a rich ore strike in the 1870s, and are still mined today. Their flaming color is due to the highly oxidized iron content of the base rock. Red Mountain Pass is Colorado's most spectacular and famous paved pass, high and exposed at the summit, surrounded by gorgeous slopes and precipitous drops into the Uncompahgre River Canyon. Proceed with caution at the top, where the road is narrow, rough, and without guardrails.

- **"The Million Dollar Highway"** is a 12-mile stretch of white-knuckle driving between Red Mountain Pass and Ouray that follows Otto Mears's original toll road. Known as "the Pathfinder of the San Juans," Mears (1840–1931) built more than 300 miles of rail and toll roads, linking the early mining camps and towns of the San Juan Mountains to each other and to points beyond. Descend with extreme caution through the Uncompahgre Gorge into Ouray, for this narrow, steep, and perilous maze of switchbacks and hairpin turns has no guardrail.

- **Ouray** (7,710 feet), called "the Switzerland of America," is nestled beneath craggy peaks and best known for its natural hot springs and the Box Canyon Falls. The perpendicular walls of Box Canyon rise 221 feet with a span of only 21 feet, creating a high, narrow gorge. As mountain snow melts, the runoff pours into Canyon Creek and thunders through this tight crack, dropping 285 feet with deafening force.

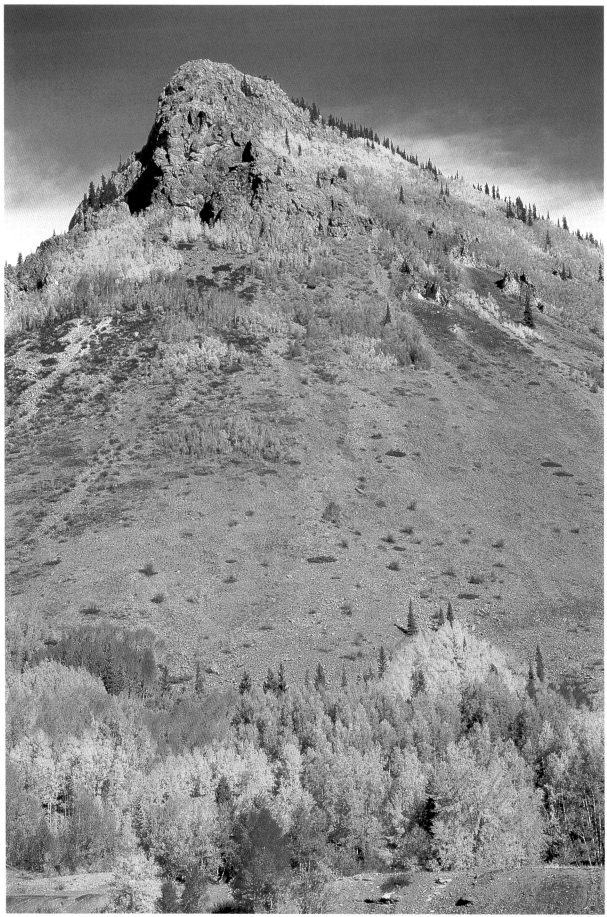

In Silverton

- **Mount Sneffels** (14,150 feet) and the Sneffels Range are named for the Icelandic volcano in Jules Verne's *Journey to the Center of the Earth*, which was depicted as the entrance to the planet's core.

- **Dallas Divide** (8,970 feet), Dallas Peak (13,809 feet), Hastings Mesa, East Dallas Creek Road, and Last Dollar Road into the Mount Sneffels Wilderness Area, a spectacular montane valley of grassy meadows covered with gorgeous stands of aspen, thick and mature, and threaded by creeks lined with cottonwoods, willow bushes, and scrub oak. Spruce and fir forests rise up the dark and rugged slopes of the Sneffels Range that tower over this wild backcountry, considered the most beautiful in all of Colorado.

- Don't miss this oddity! Along the stretch of CO 145 heading east from Placerville to Telluride, it seems completely certain that you are on a constant descent until you happen to glance out the window and notice the San Miguel River rushing downhill . . . in the opposite direction of your travel!

- **Telluride** (8,750 feet), named for tellurium but affectionately called "To-Hell-You-Ride," is an old mining town tucked into the interior of a large box canyon, walled on three sides by a near-vertical mile of the Uncompahgre Mountains. At the farthest end is Bridal Veil Falls, Colorado's highest unbroken waterfall, which streaks down 365 feet into the San Miguel River. Telluride was the first electrified town in the world, and the renovated 1907 Westinghouse generator still runs, perched on the edge of a cliff above Bridal Veil Falls.

- **Wilson Peak** (14,017 feet), Sunshine Mountain (12,930 feet), and the granite pinnacles of the Ophir Neeedles (12,452 feet), all in the San Miguel Range.

- **Lizard Head Peak** (13,113 feet) is a single 800-foot column of volcanic rock atop Lizard Head Pass (10,222), a wide-open subalpine ridge where storm clouds linger.

- **Mesa Verde National Park,** 10 miles east of Cortez. (See Mesa Verde National Park.)

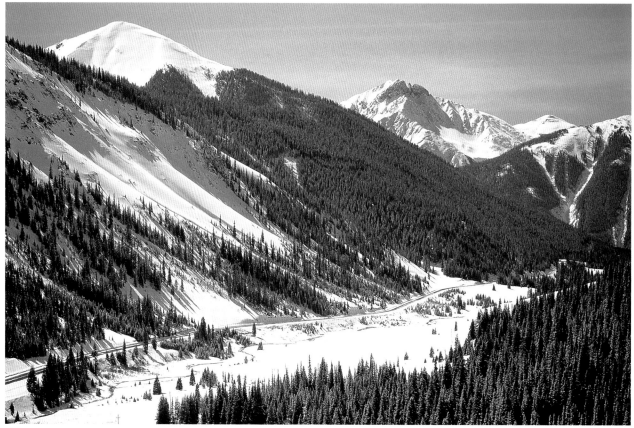

67 *Leaving Silverton for Ouray: South Lookout Peak, South Mineral Creek, and Mineral Creek Valley in the winter*

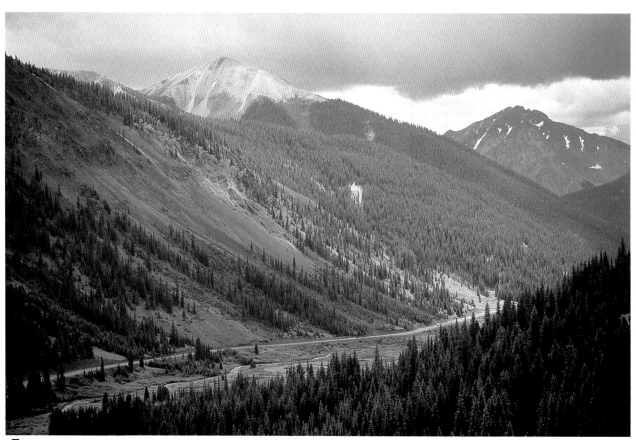

68 *South Lookout Peak, South Mineral Creek, and Mineral Creek Valley in the summer*

COLORFUL NOTE

After a disastrous and deadly expedition in the winter of 1848, explorer Colonel John C. Frémont described the San Juans as "the highest, most rugged, most impractical and inaccessible of the Rocky Mountains."

GENERAL INFORMATION

FEE:	No	CONVENIENCE STORE:	Yes
VISITOR CENTER:	Yes	HIKING:	Yes
4WD NEEDED:	No	CAMPING:	Yes
GAS WITHIN 5 MILES:	Yes	LODGING WITHIN 5 MILES:	Yes
RESTROOMS:	Yes	PHOTO RATING (1–5):	5
FOOD/WATER:	Yes	CHILD RATING (1–5):	5

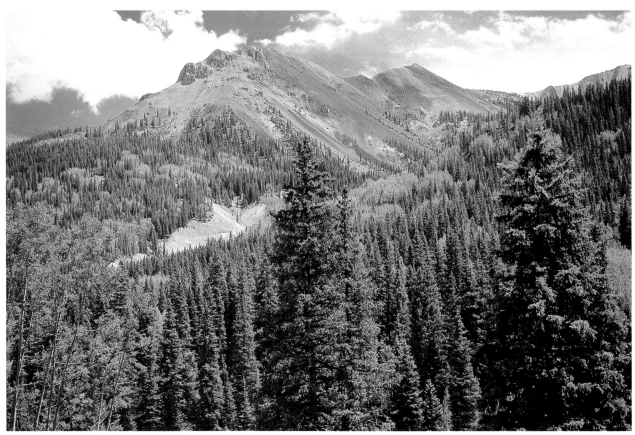

69 *Red Mountain*

70 *Near the Red Mountain Pass summit*

CAUTION: The San Juan Skyway is not for the inexperienced or anxious driver. The road is narrow, with blind curves, sheer drop-offs, and few places to pull over. Often there are no guardrails or shoulders. Know your limits and take your time; look for a pull-off but do not feel rushed if someone wants to pass you. Use low gear rather than brakes for descending. The crisp, rarefied mountain air can lead to altitude sickness.

FOR MORE INFORMATION

Durango (800) 525–8855
Silverton (800) 752–4494
Ouray (800) 228–1876
Telluride (800) 525–3455
 (888) 605–2573
www.silverton.org
www.ouraycolorado.com
www.telluridestyle.com
www.visittelluride.com

71 *On Red Mountain Pass*

72 *Yankee Girl Shafthouse near Red Mountain Pass*

73 *Mount Sneffels*

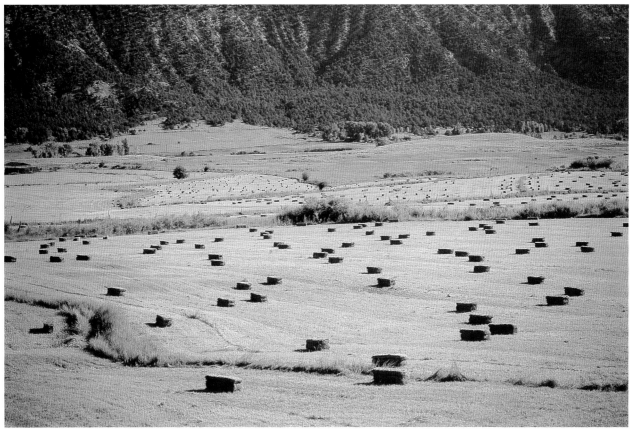

74 *Hay bales in Pleasant Valley*

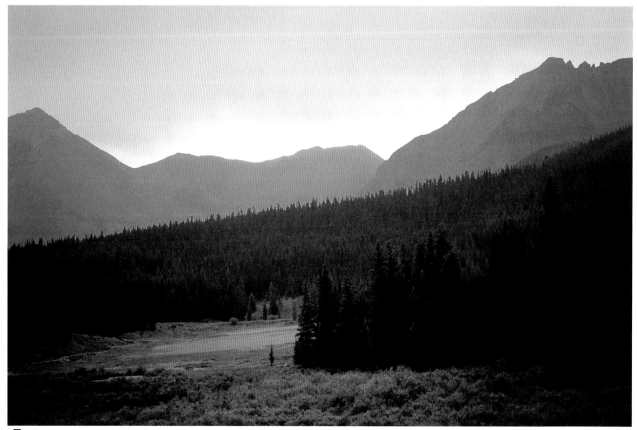

[75] *Yellow Mountain*

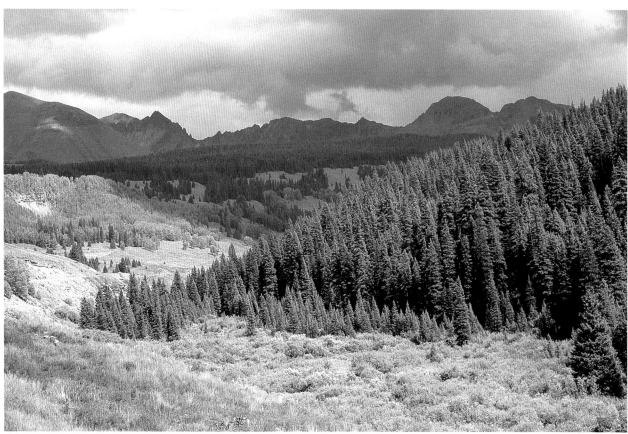

[76] *Near Lizard Head Pass*

Near Cortez

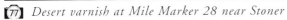 *Desert varnish at Mile Marker 28 near Stoner*

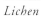 *Unaweep Canyon*

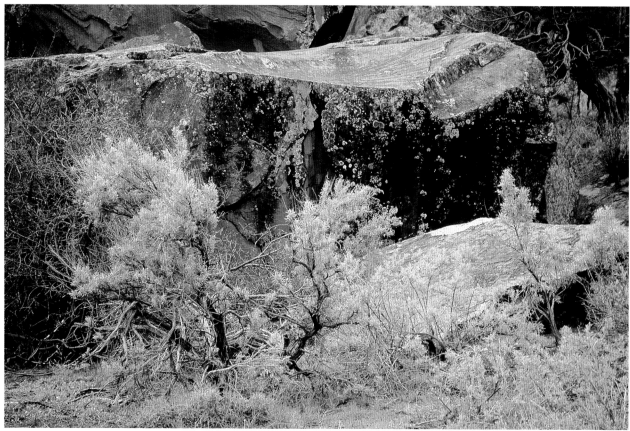

Lichen

UNAWEEP–TABEGUACHE
Scenic and Historic Byway (CO 141)

LOCATION: Between Whitewater and Naturita, Colorado

ELEVATION: Ranges from about 4,600 feet at Gateway to 6,600 feet

UTE NAMES: *Unaweep*—"thorny canyon" or "where land comes together," also "canyon with two mouths" (for East Creek and West Creek); *Tabeguache*—"people who camp on the sunny side of the mountains"; *Uncompahgre*—"hot water spring" or "the place with red water"

LOCAL MAP: The Unaweep–Tabeguache Scenic Byway (CO 141) begins 10 miles south of Grand Junction on US 50.

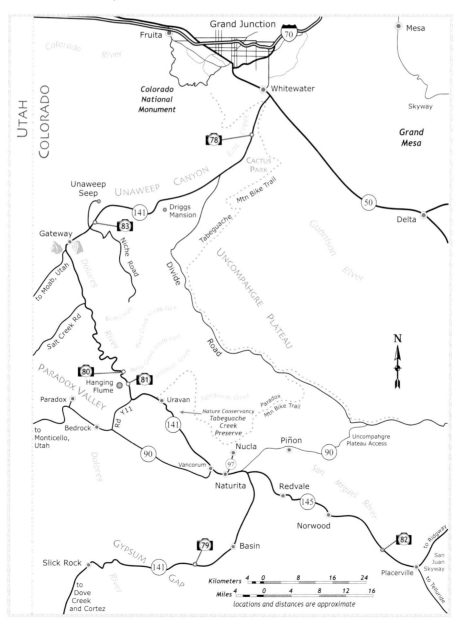

79 *Gypsum Gap (6,100 feet), south of Naturita on CO 141*

80 *Desert varnish at Mile Marker 83*

GEOGRAPHY: Before the uplift of the Uncompahgre Plateau thirty million years ago, Unaweep Canyon was likely the riverbed of the great Gunnison River, lined with craggy fractured walls of dark gray Precambrian granite, schist, and gneiss. It makes a giant U-shaped slash across the entire Uncompahgre Plateau, a slice so deep, wide, and empty that it is clearly the work of a river far more powerful and erosive than the two tiny creeks that drain it today. Curiously, these two creeks, East Creek and West Creek, flow in opposite directions from the midpoint of the canyon and drain opposite ends, making Unaweep the only canyon known in the world to have such a watershed divide within its middle. The Unaweep–Tabeguache Scenic and Historic Byway winds across the northeastern fringe of the Colorado Plateau, along the broad floor of Unaweep Canyon, and then follows the deeply eroded chasm cut by the Dolores River. It is a scene of granite and sandstone, gray, deep red, and tan, of abrupt cliffs and rippling green meadows, of lichen and water, of massive angular boulders strewn about sandy slopes, of pinyon and juniper on high rocky ledges, and of long grassy valleys filled with willow and cottonwood.

SUGGESTED LENGTH OF STAY: 3 hours, not including stops

BEST TIME TO BE THERE: May, September, or October

HIGHLIGHTS:

- Mile Marker 154: Begin in Whitewater at the junction of US 50 and CO 141 and cross the Gunnison River.

- MM 152: Narrow tree-lined East Creek in Unaweep Canyon, with tawny-brown, ledgy Dakota sandstone; large boulders dotted with lichens and striped with mineral varnish in purple, sage, and tan.

- MM 151 to 150: Lower Unaweep Canyon widens and opens up to a flatland strewn with enormous lichen-spotted boulders, juniper, and pinyon pine.

- MM 149: Immense rocks speckled with lichen, and a long view of Unaweep Canyon.

- MM 146: A slow ascent of Ninemile Hill to Grand Valley Overlook.

- MM 145: Cactus Park, where the Gunnison and Colorado Rivers are believed to have once found confluence.

- MM 144.5 to 143: The heart of Unaweep Canyon; deep rust-red Wingate sandstone cliffs on sloped Chinle formation bases, heavily striped with desert varnish. It is greener and grassier here. Mature cottonwoods and willow thickets line East Creek.

- MM 139.5 to 138: Low trees beneath outcroppings of steep sheer vertical cliffs of Kayenta sandstone, crosshatched and heavily striped.

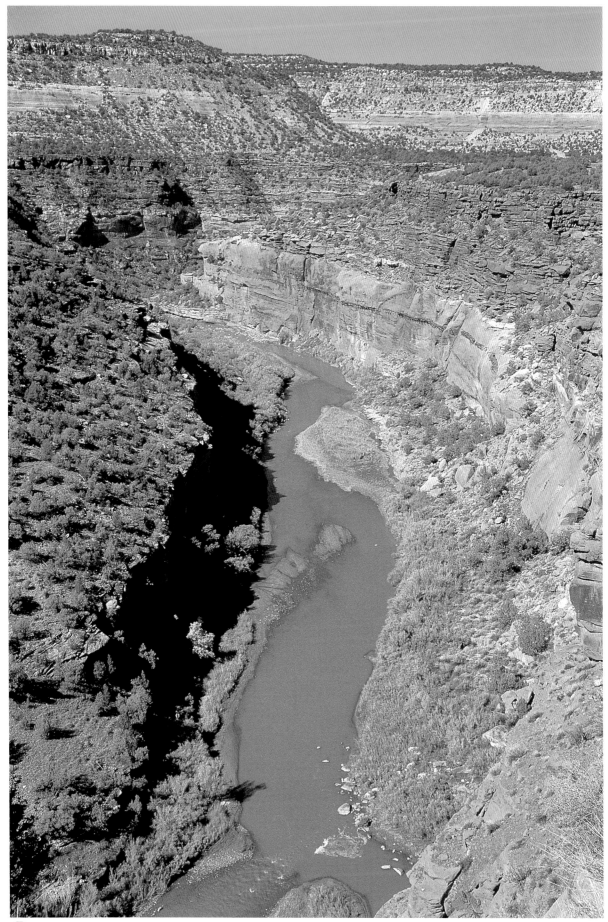

81　*The Hanging Flume suspended above the Dolores River*

- MM 137.5 to 137: To the west, the dark granite walls of the canyon are strongly marbled with pale pegmatite dikes on a scale much smaller than but similar to the Painted Wall in Black Canyon of the Gunnison.

- MM 134.8 to 134: Unaweep Divide (7,048 feet), the drainage divide that separates East Creek from West Creek; wide, flat, and open with brown cliffs.

- MM 130: Thimble Rock, composed of Precambrian schist and granite.

- MM 129.5: The iron and stone ruins of Driggs Mansion, built in the early 1900s beneath towering Thimble Rock.

- MM 127.5: Aspen groves and green, rolling Gill Meadows.

- MM 121: A sudden descent into the Unaweep Seep, filled with cottonwoods, willows, box elders, and wildflowers.

- MM 119.8: The Unaweep Seep, bright green and grassy, is a series of lush marshland springs created by West Creek as it cuts into the canyon floor and reveals the underlying water table. Also known as Swamp Hill, this area is home to the rare, 4-inch orange Nokomis fritillary butterfly.

- MM 116.8: West Creek Picnic Area and rest stop.

- MM 115.5: The Uncompahgre Fault; a sudden long view of red Wingate cliffs on Chinle slopes, with the laccolithic La Sal Mountains of Utah in the distance.

- MM 111.5: The Palisade, an enormous fin of Wingate sandstone, towers above the tiny town of Gateway, where the Unaweep Canyon and the Dolores Canyon meet.

- MM 110.5: John Brown Canyon; the surrounding mesa is cut into a series of buttes.

- MM 101 and MM 98.3: The gorgeous Dolores River Canyon.

- MM 99: Boulder-filled fields beneath vertical cliffs.

- MM 88.5: Cross the Dolores River.

- MM 83 to 82.7: Massive sandstone overhang with broad mineral streaks in a gingham plaid of delicate hues in tan, buff, violet, and pink.

- MM 81.5: Hanging Flume Overlook, with information about the history of local mining and the construction of a wooden flume still suspended from the steep canyon wall high above the Dolores River. The river descends into a narrow, deep gorge as the road climbs to the rim, covered with pinyon pine, juniper, and scrub trees.

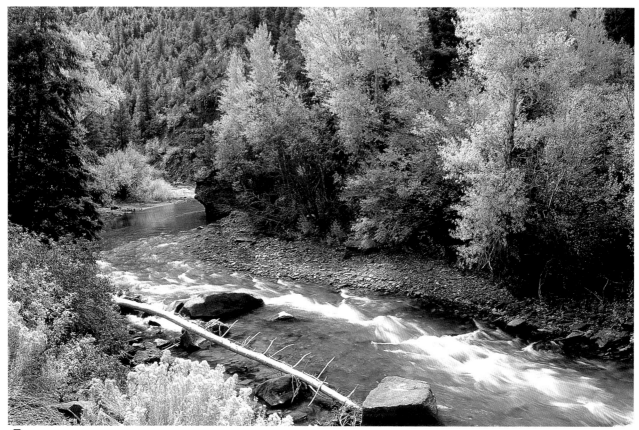

82 *The San Miguel River along CO 145, east of Naturita*

83 *Sunflower at the Unaweep Seep*

- MM 80: Heavily banded sandstone in descending horizontal layers: ledges of pale brown Dakota sandstone topped with scrub trees and pinyon, white Navajo sandstone, orange "Swiss cheese" Kayenta sandstone, and deep red, varnished Wingate sandstone at the base.

- MM 77.5: The canyon flattens out, and the road turns to follow the San Miguel River.

- MM 74.2: Cross the San Miguel River.

- MM 61 to 60: Enter the town of Naturita, founded in 1881, now with full services and a large information sign about the Unaweep–Tabeguache Scenic and Historic Byway.

COLORFUL NOTE

There is some speculation by geologists that both the Colorado and Gunnison Rivers once exerted their mighty force here, joining at the mouth of Cactus Park and slicing down into ancient stone to create Unaweep Canyon.

GENERAL INFORMATION

FEE:	No	CONVENIENCE STORE:	No
VISITOR CENTER:	No	HIKING:	Yes
4WD NEEDED:	No	CAMPING:	No
GAS WITHIN 5 MILES:	No	LODGING WITHIN 5 MILES:	No
RESTROOMS:	No	PHOTO RATING (1–5):	3
FOOD/WATER:	No	CHILD RATING (1–5):	1

CAUTION: There are no reliable services along this very remote 94-mile stretch of CO 141.

FOR MORE INFORMATION

Bureau of Land Management
Grand Junction Resource Area
764 Horizon Drive
Grand Junction, CO 81506
(970) 243–6561

Bureau of Land Management
2815 H Road
Grand Junction, CO 81506
(970) 243–3000